Thoughts & Sketches

Gates & Gardens

a *Write The Light In* write/color/sketch journal

LK Hunsaker

ElucidatePublishing.net

Thoughts & Sketches: Gates & Gardens. ©2015 LK Hunsaker. All Rights Reserved

ISBN 978-1-329-59986-4

Also available as a 200 page coil bound edition and 64 page pocket edition. See ElucidatePublishing.net for details.

All artwork in this journal was hand drawn by the author using actual objects, photos, and memory as references. They may be printed by the purchaser for your own personal use. They may not be distributed in print or electronically without written permission from the publisher.

The prompts in this journal were created by the author and are meant as encouragment and exploration. The author/publisher assumes no liability for use of prompts. LK Hunsaker is not a licensed therapist and this book is not meant to be or replace professional therapy. Please seek help if you feel you cannot handle things on your own and/or have continual and lasting negative thoughts.

Elucidate Publishing
PO Box 1262
Hermitage PA 16148

| Date/Title | Introduction | September 2015 |

 I have journalled off and on for years, at times in plain notebooks, other times in pretty bound journals. Often, what kept me from writing that first sentence, or my name, in a pretty journal was that it was too pretty to "mess up" with my scrawlings. Those perfect, beautiful books were intimidating. They were also confining. Either all lined or unlined, they didn't fit my different journaling needs. I'm a doodler—always was. Sometimes I need images, even non-sensical designs, to clarify my thoughts. Sometimes I appreciate prompts, but I don't want to be confined by "write this here" journals, either.

 So this is my answer: a non-perfect hand-drawn image coloring/doodling/writing/sketching journal space meant to be used however you like. Draw over the lined pages if you wish. Write over the blank pages. Use pencil, pen, colored pencils, or crayons (markers may bleed through). Add to the printed images or just color them as they are. Use them as writing prompts, or don't.

 Write. Create. Explore. Express.
 Most of all, Enjoy!

 Loraine (aka LK Hunsaker)

P.S. The prompts are in the middle, marked with gray edges to bind easily.

Dedicated To
Punkindoodle
+
Ladybug

Date/Title

Date/Title

Date/Title

Date/Title

Date/Title

Date/Title

Date/Title

Date/Title

Date/Title

Date/Title

Date/Title

Date/Title

Date/Title

Date/Title

Date/Title

Date/Title

Date/Title

Date/Title

Date/Title

Date/Title

Date/Title

Date/Title

Date/Title

Date/Title

Date/Title

Date/Title

Date/Title

Date/Title

Date/Title

Date/Title

Date/Title

Date/Title

Date/Title

Date/Title

Date/Title

Date/Title

Date/Title

Date/Title

Date/Title

Date/Title

Writing Prompts

A few ideas to get started..
~ ~ ~ ~

What is your current biggest struggle? Write a happy ending that may come from getting through the struggle.

How many bricks are in your self-protection wall? Choose one, write it down, and then write about the possible consequences of plucking it out of your wall, bad and good. Then write why it should or shouldn't stay where it is. Go on to the next.

What have you discovered about yourself lately that you don't want to admit, or that you'd love the world to know?

What do you know about yourself that others don't see? Why don't they?

Write about a silent battle you have won.

Write about where you want to be, physically or mentally, or both.

Use your favorite color (crayon, pen, marker, colored pencil) to write a list of things you like about yourself.

Describe something you tried to do that didn't work out right and jot notes on how you could have done it differently.

Copy the lyrics to one of your favorite songs, then change the lyrics to be more upbeat. You don't have to rhyme. Change it as you please.

What scares you? Jot down notes about things you can do to lessen the fear. Start with baby steps.

Write about the world you want to live in. What can you do to create that for yourself, or at least parts of it?

One person's weird is another person's normal. How do you consider yourself weird? How many others can you find/have you found who are weird in the same way?

Write about one of your scars, physical or mental. How did it help you grow?

What would you do if you weren't afraid to do it? Is the fear of possible consequences worse than being held back by that fear?

How do others see you? Is their perception accurate? Are you sure they feel that way?

When you think something negative about yourself, write it on a bit of paper. Then cross it out with big bold marker, tear it up, or burn it.

What have you done that you're particularly proud of?

Write about something you feel you must control and what might happen if you gave up that control.

Write about a journey you'd like to take.

Think of someone who has hurt you. Write what that person is dealing with on a regular basis or about a traumatic experience in their life. If you don't know, create a short story about what might cause them to act in such a hurtful manner.

Choose a piece of music and write what it means to you.

Define love. Then define hate. Make a list of the similarities and differences.

Make a list of several personal beliefs. Then write why you hold each belief.

Write a scene from the life of someone you admire. Make up what you don't know. Then do the same for someone you don't admire.

What book have you read recently that had an impact on your life or attitude? Why did you choose it?

If you could choose your own name instead of the one you were given, what would it be? Would you feel differently about yourself?

Take a walk. Anywhere. Then sit down and write about what you saw, before you do anything else.

When did you last feel like you were flying (walking on air)?

Write what is going to be great about the coming year and how you can help make it that way.

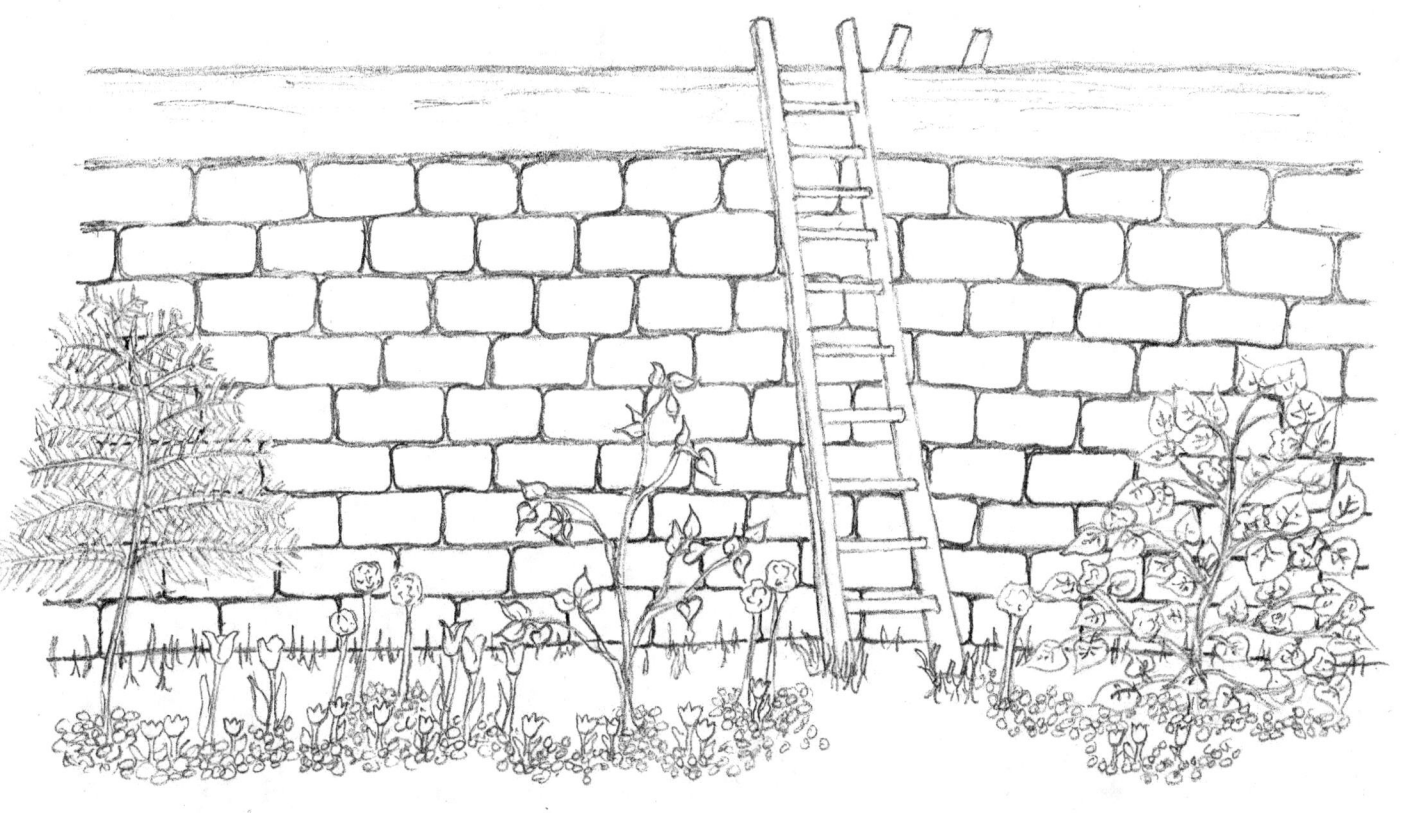

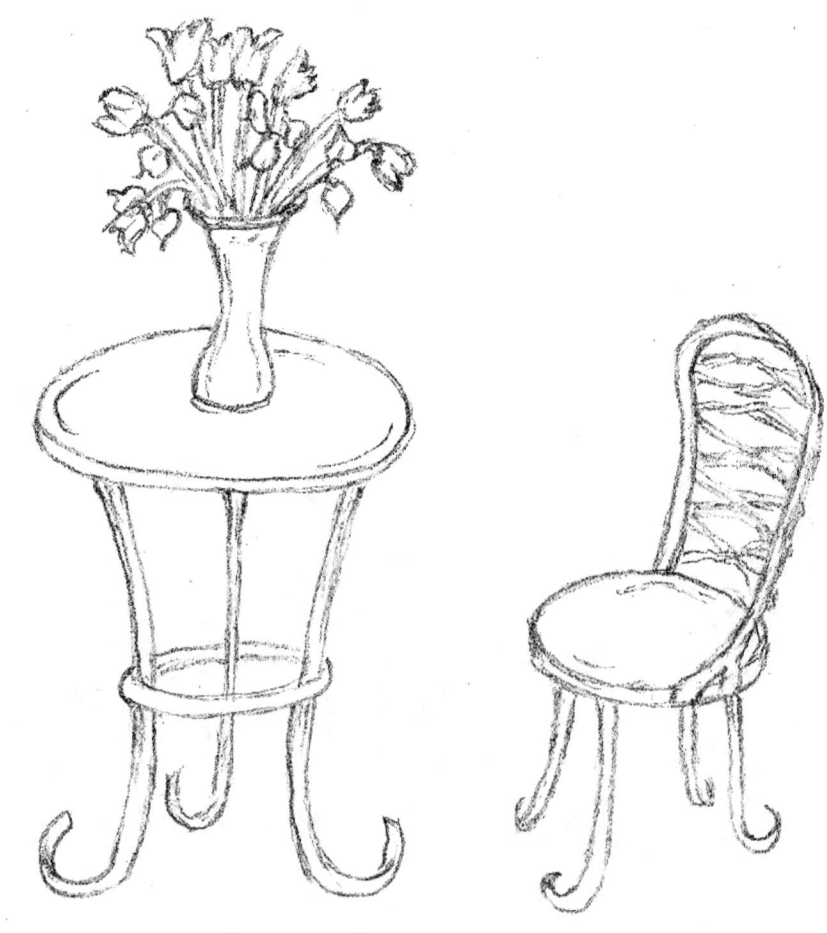

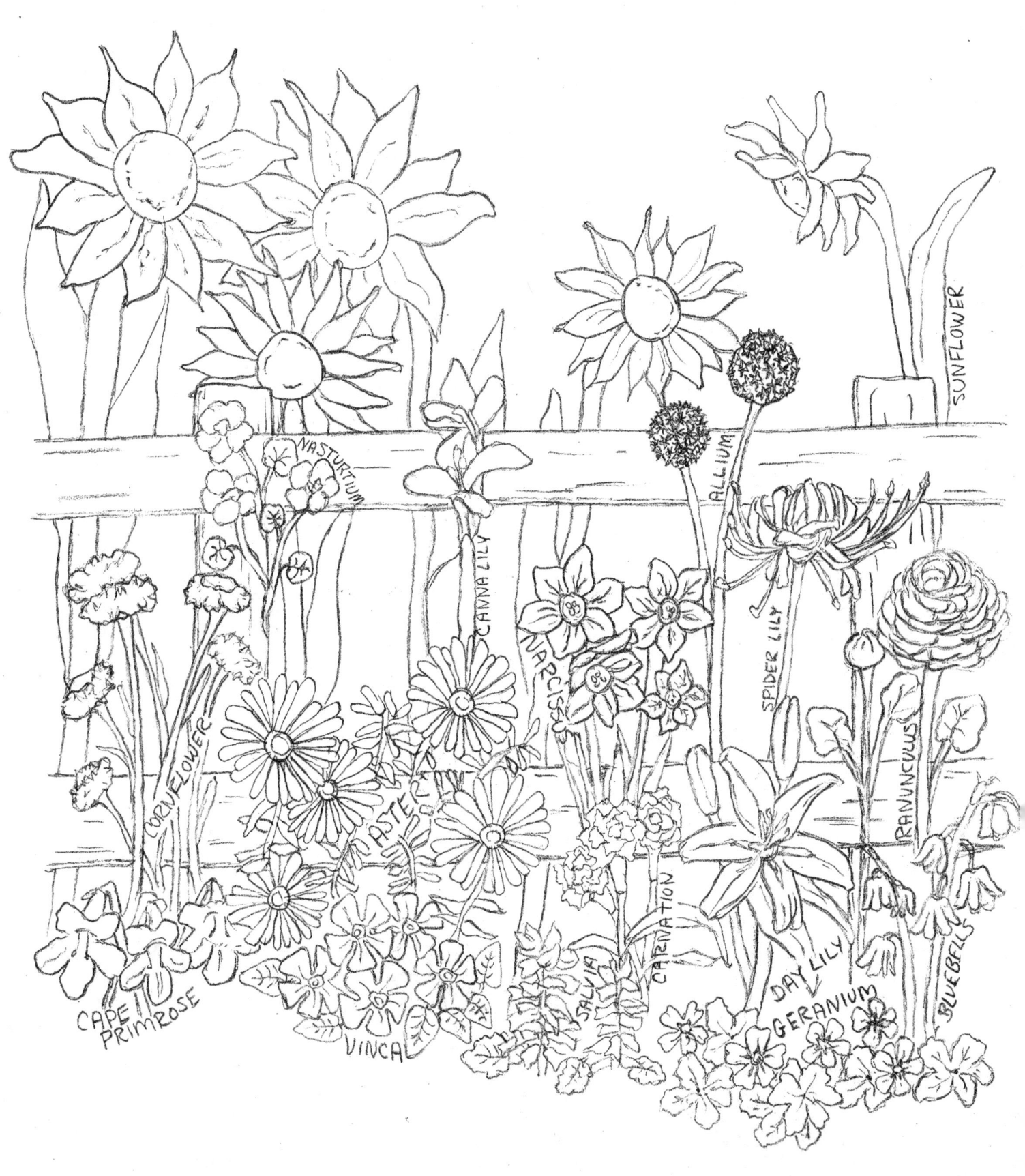

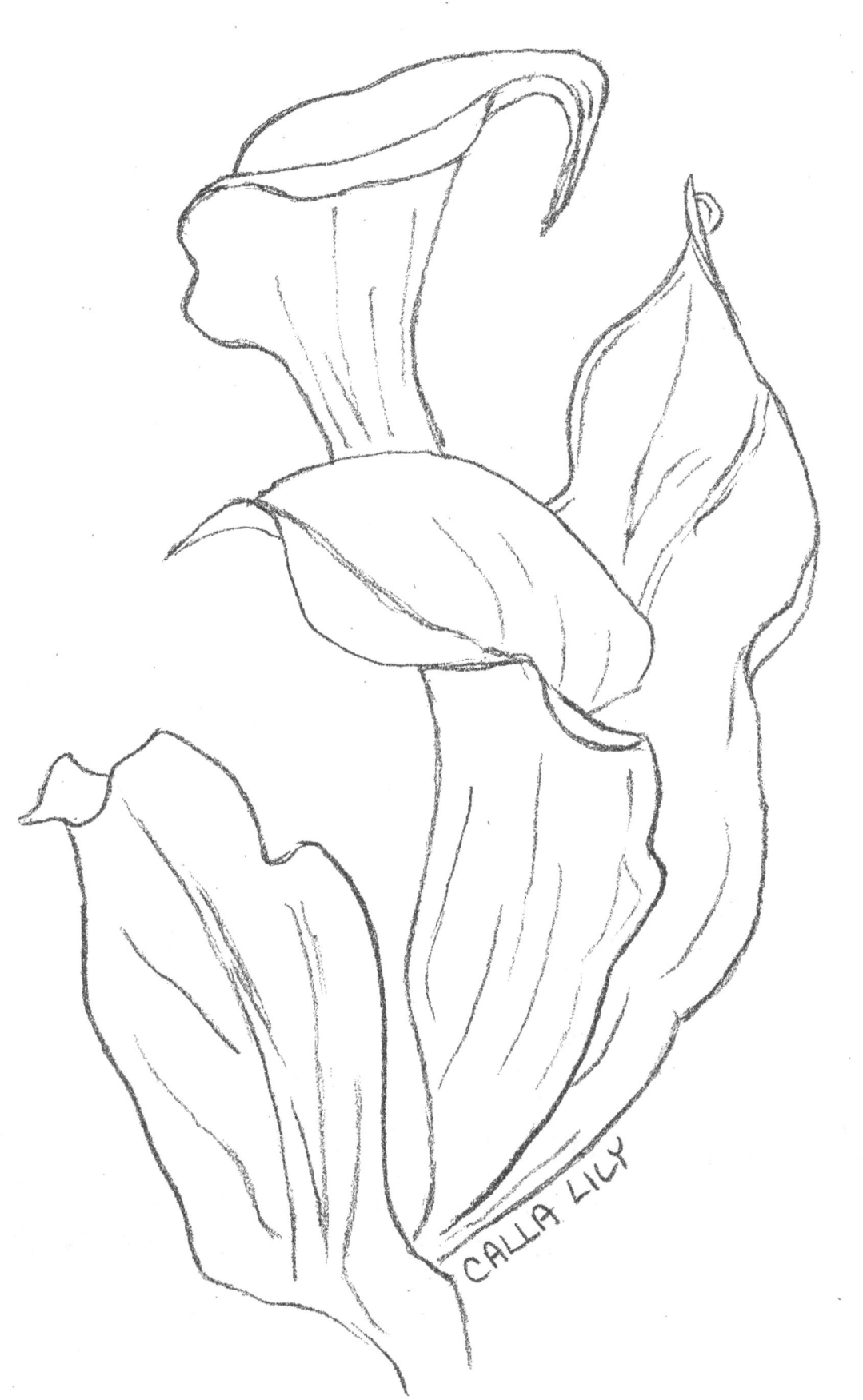

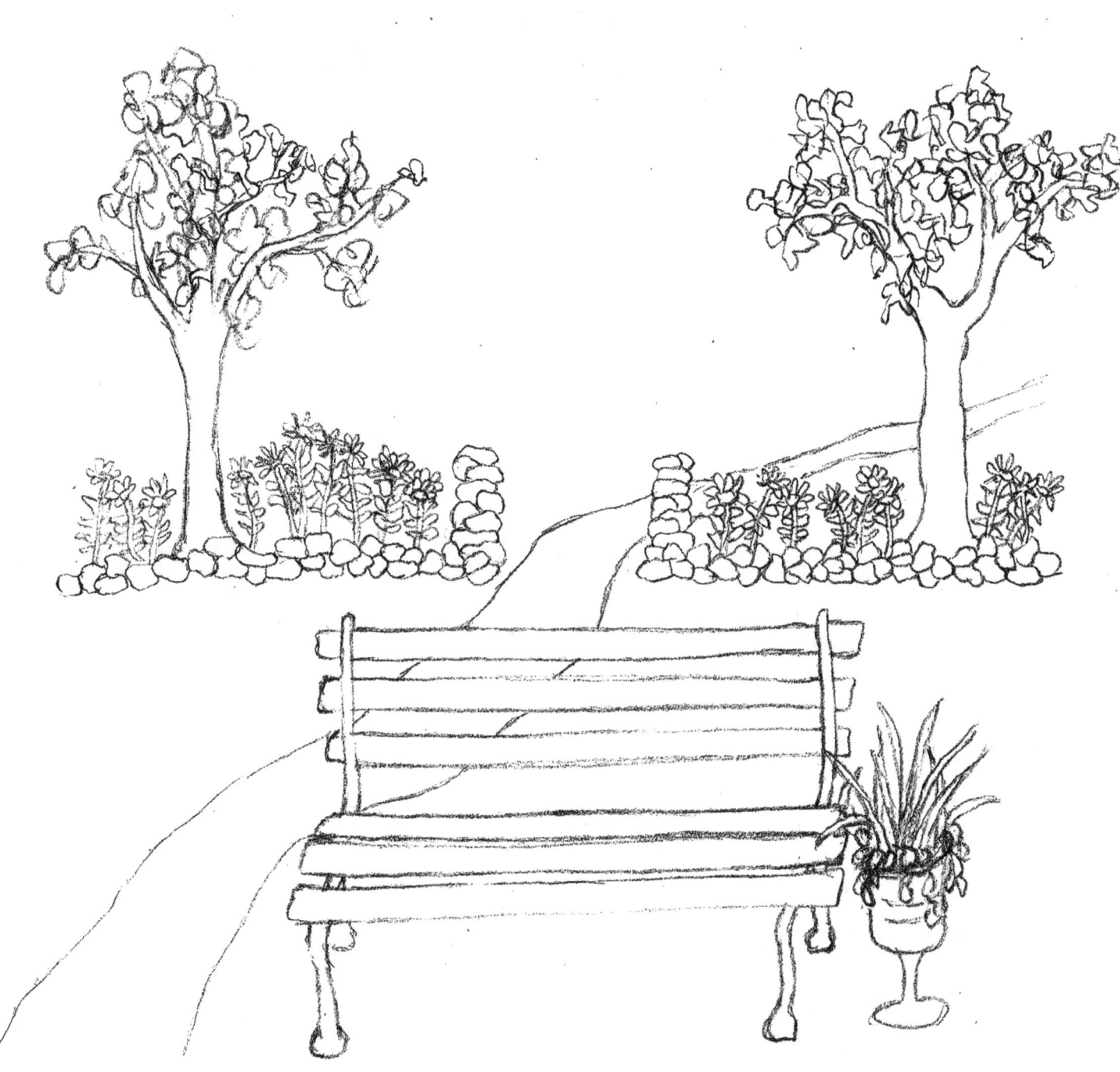

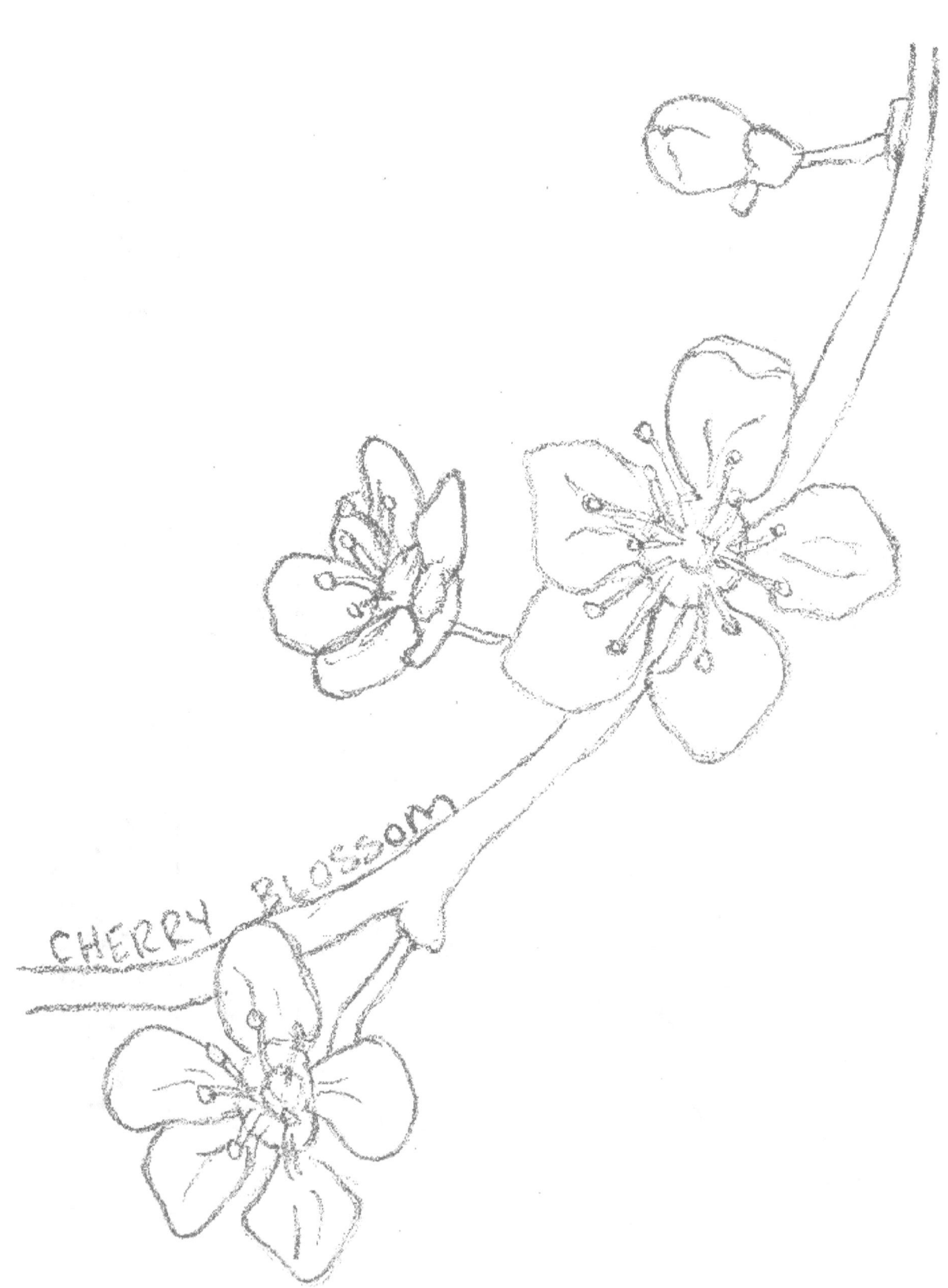

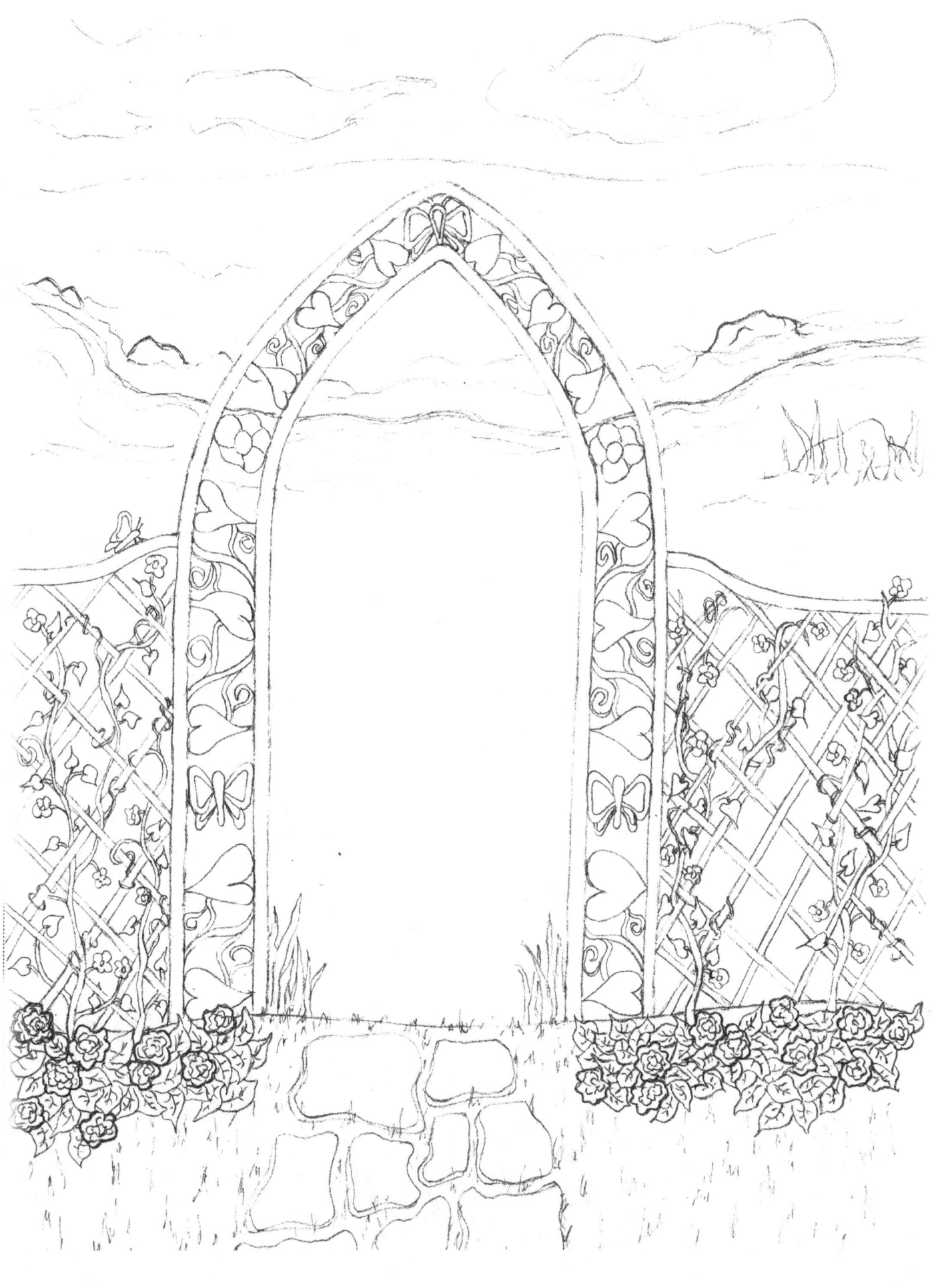

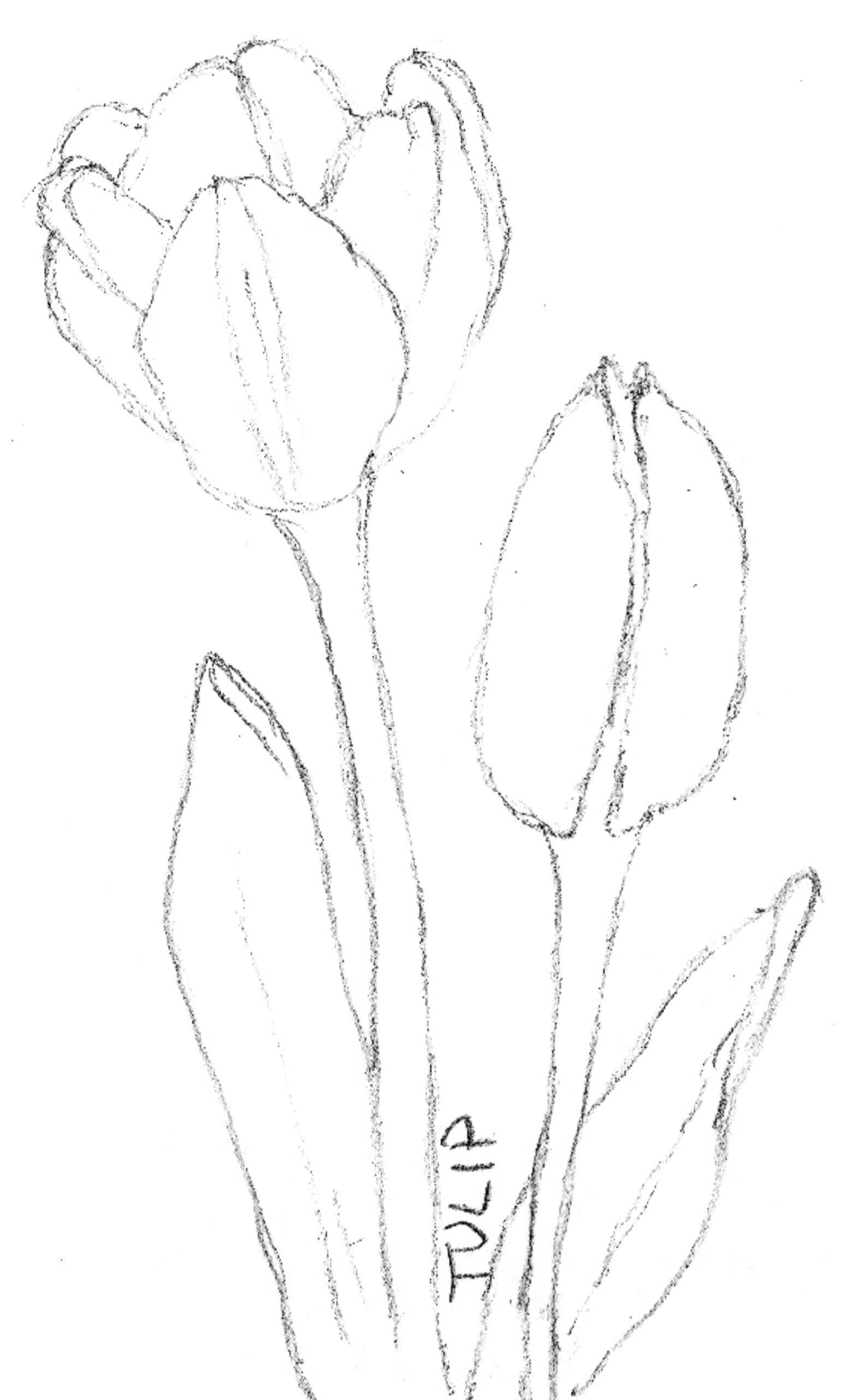

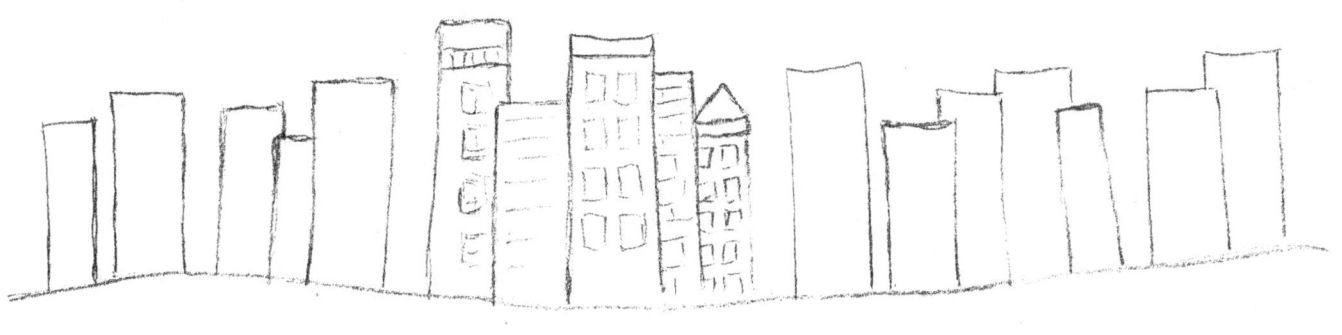

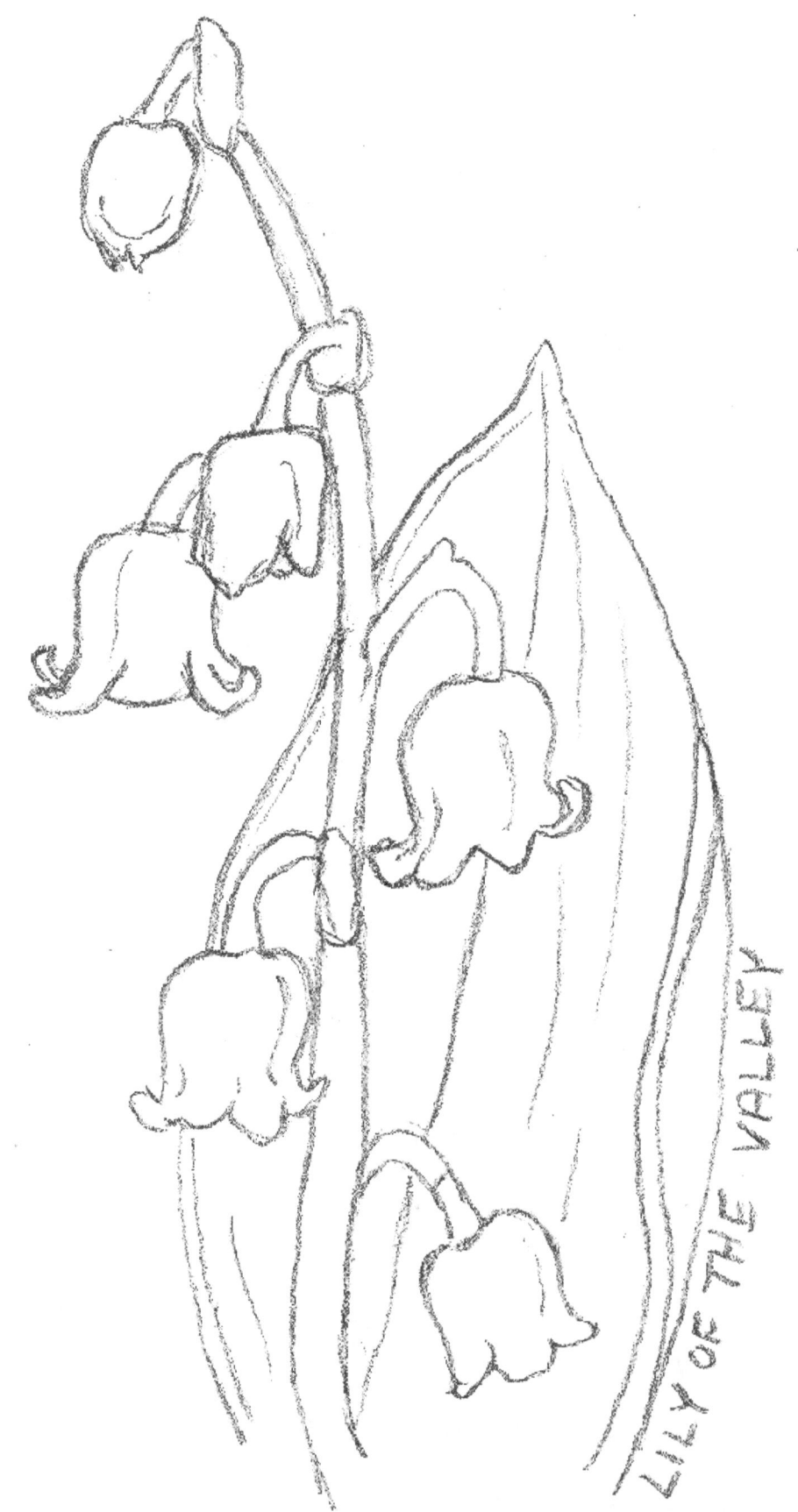

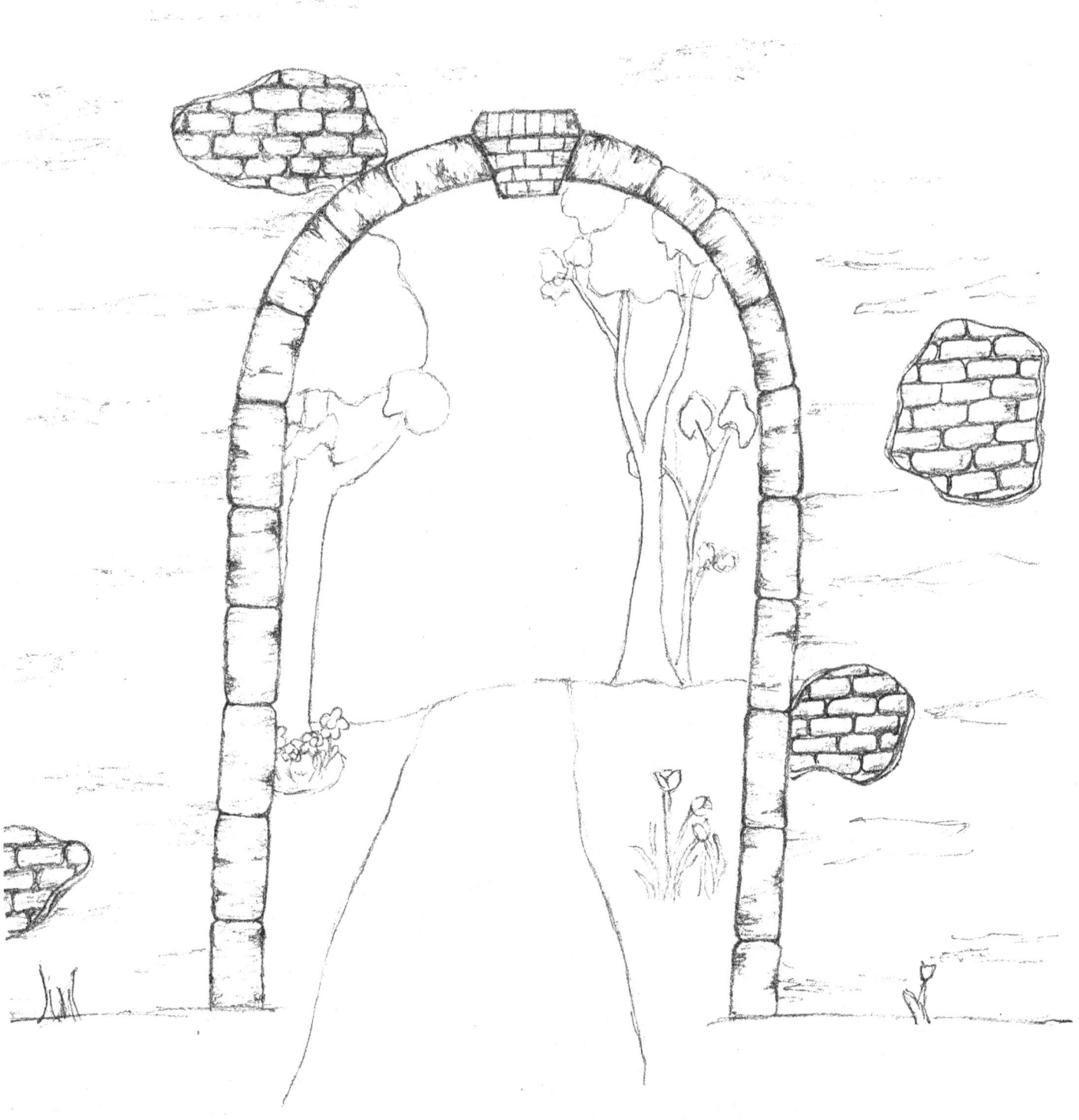

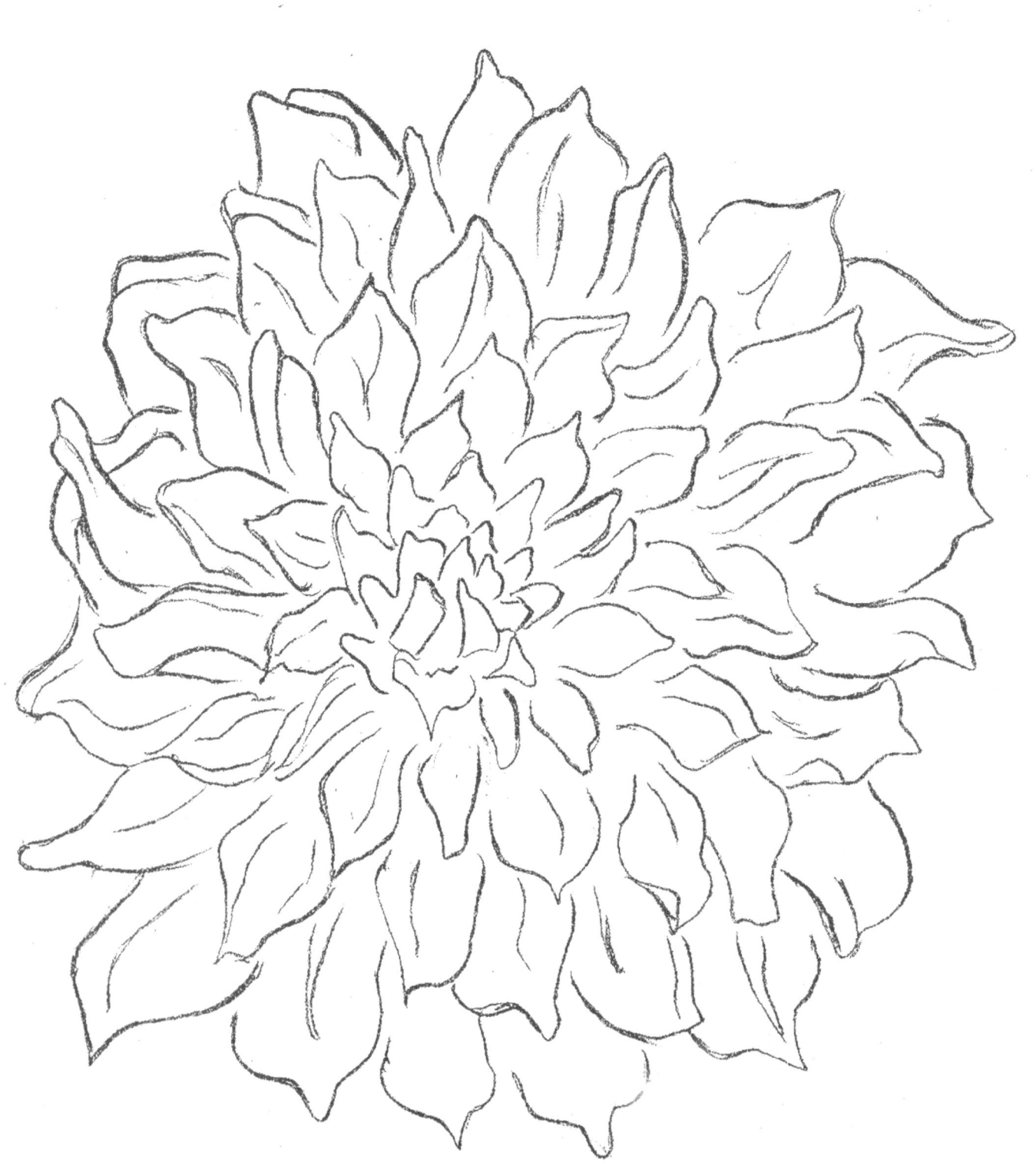

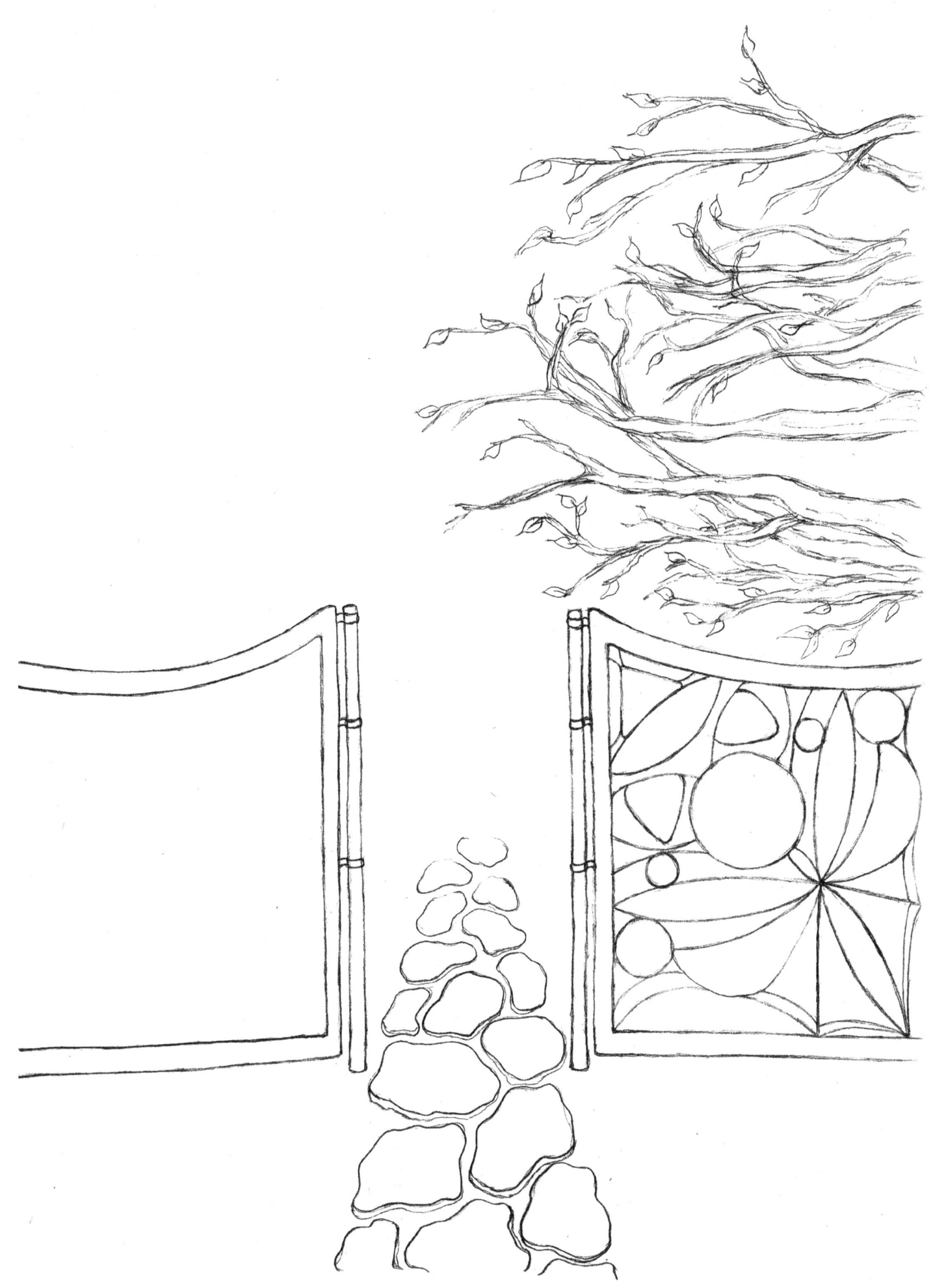

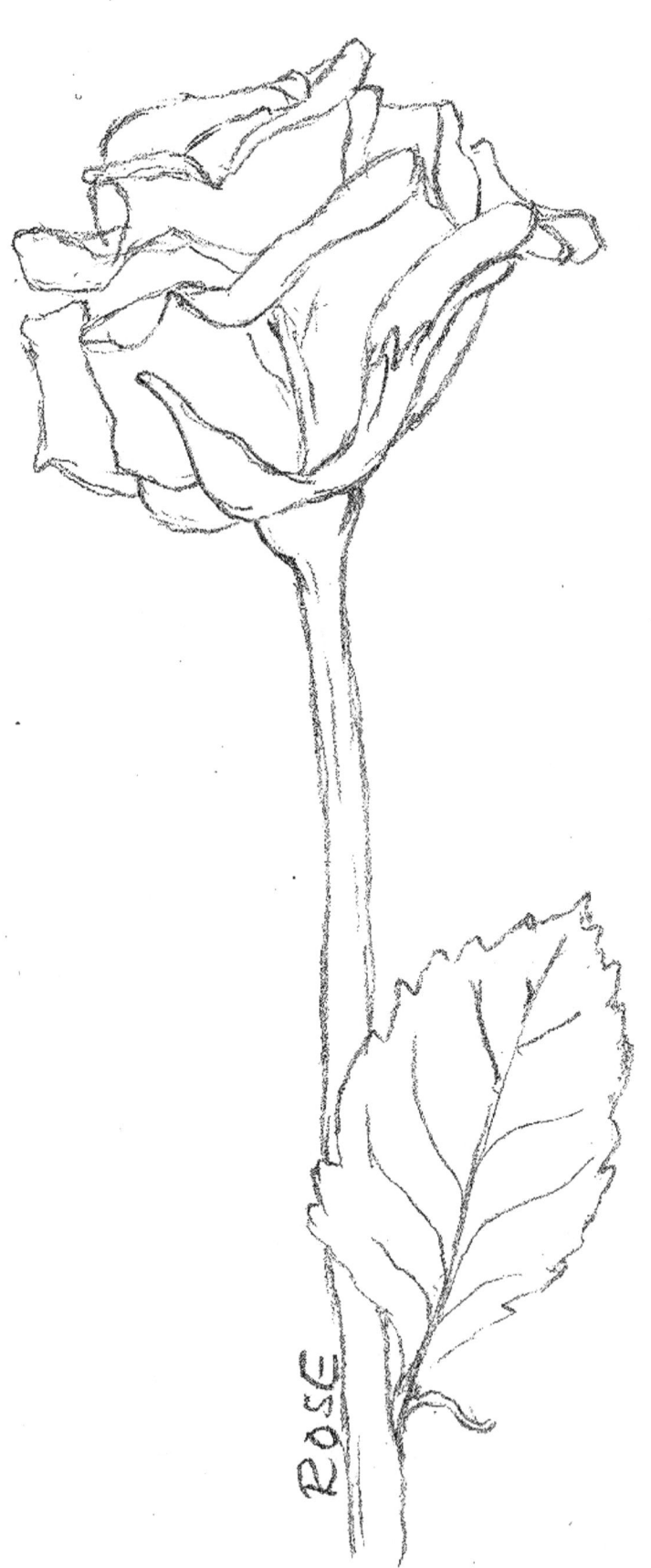

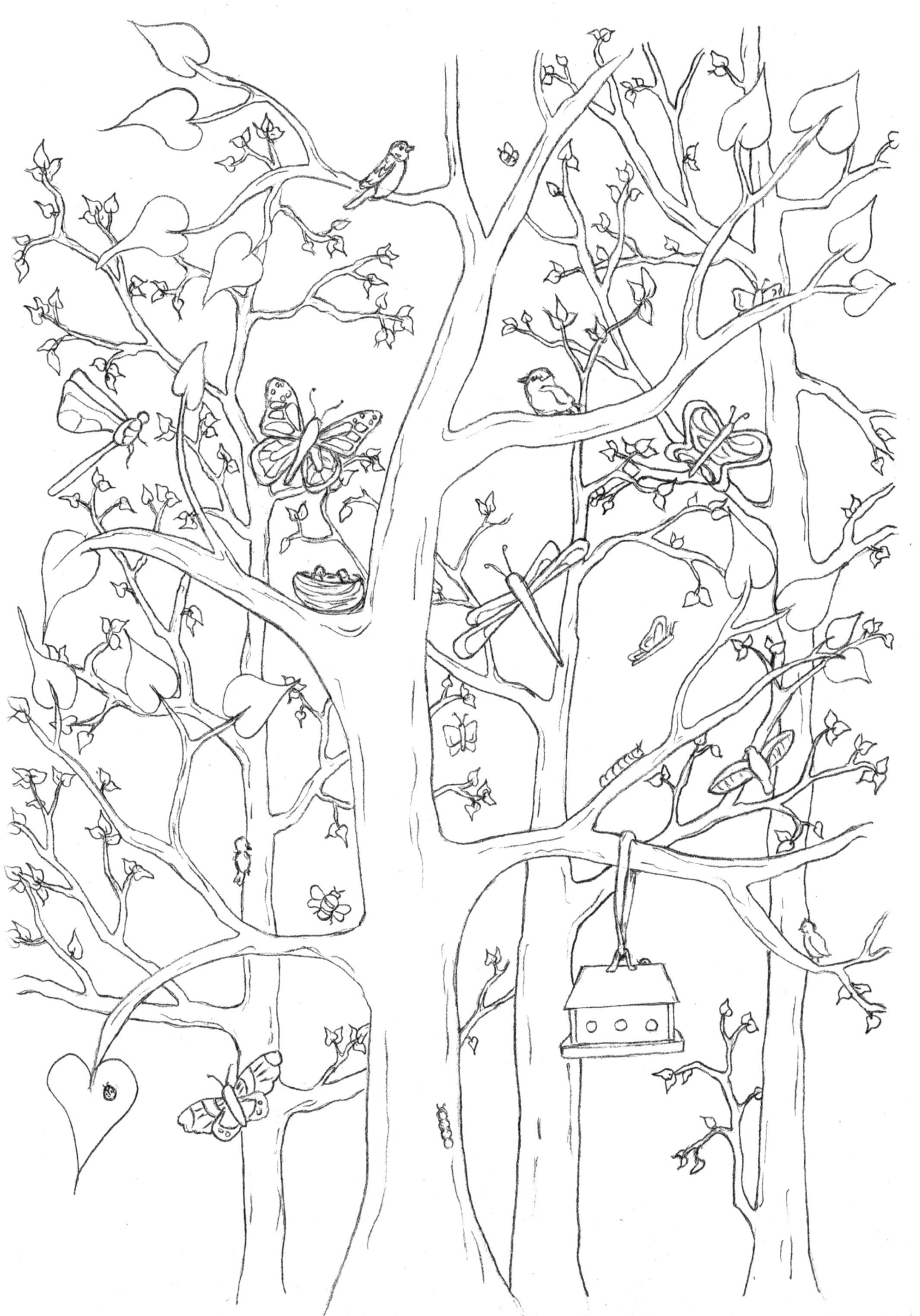

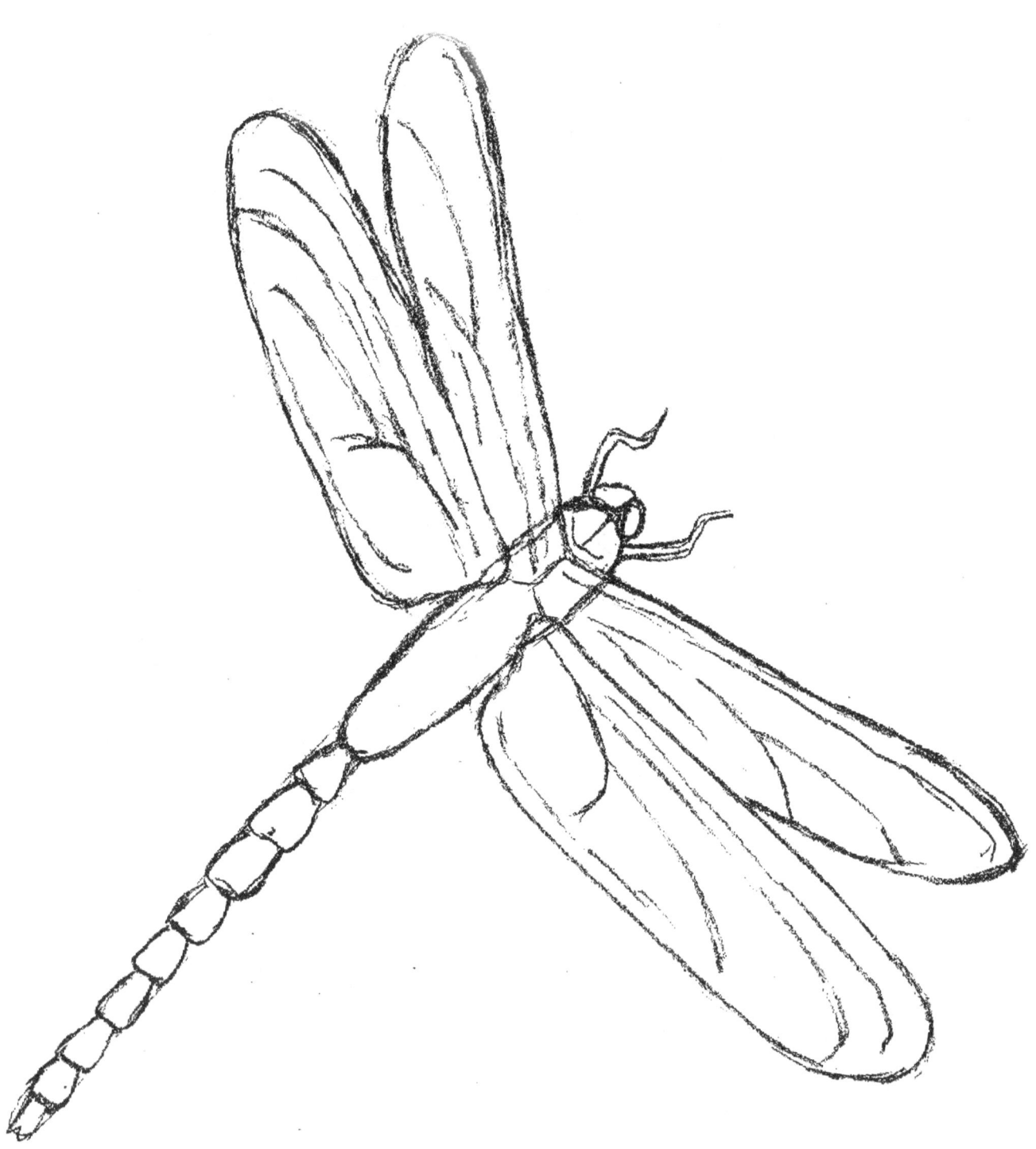

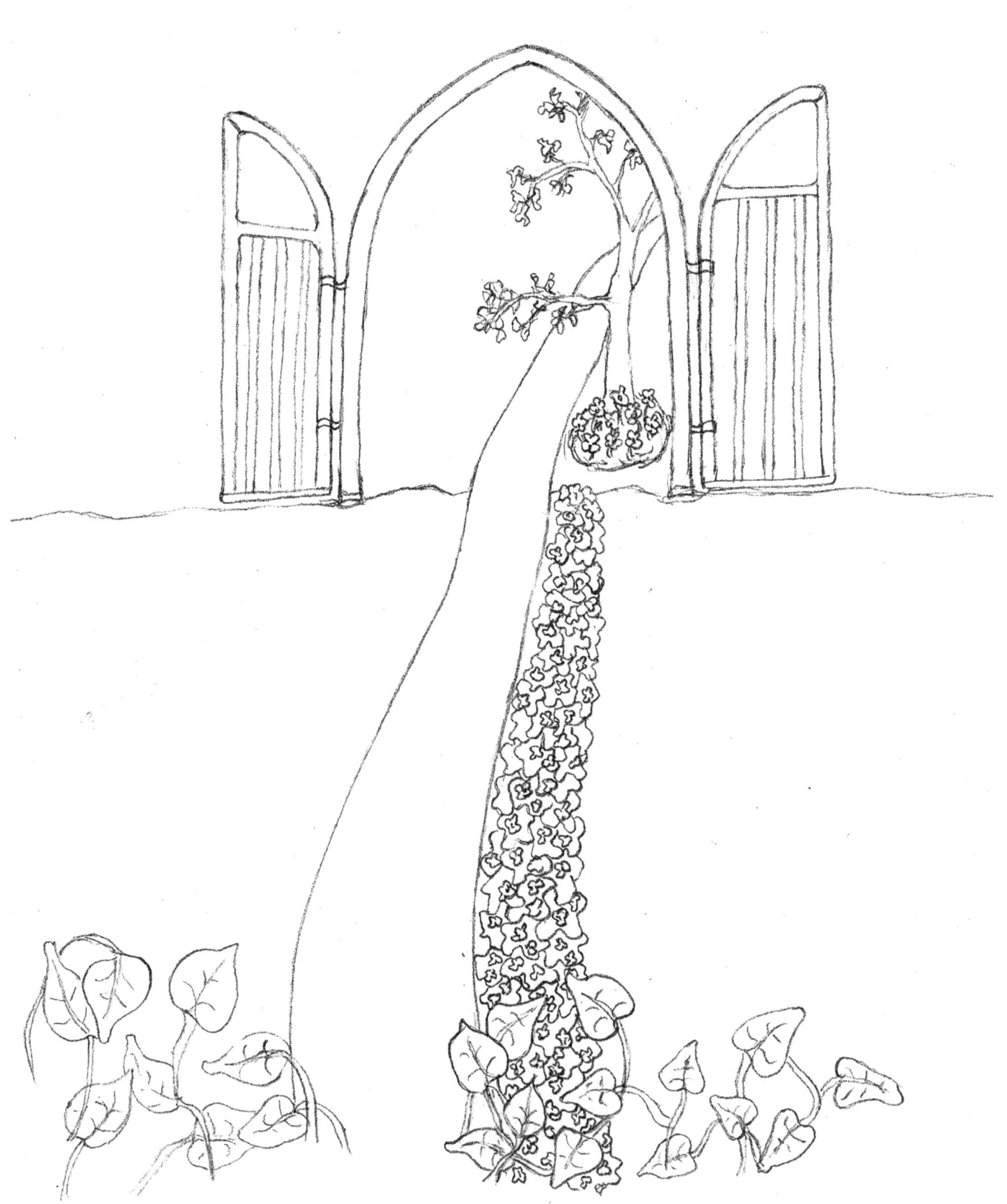

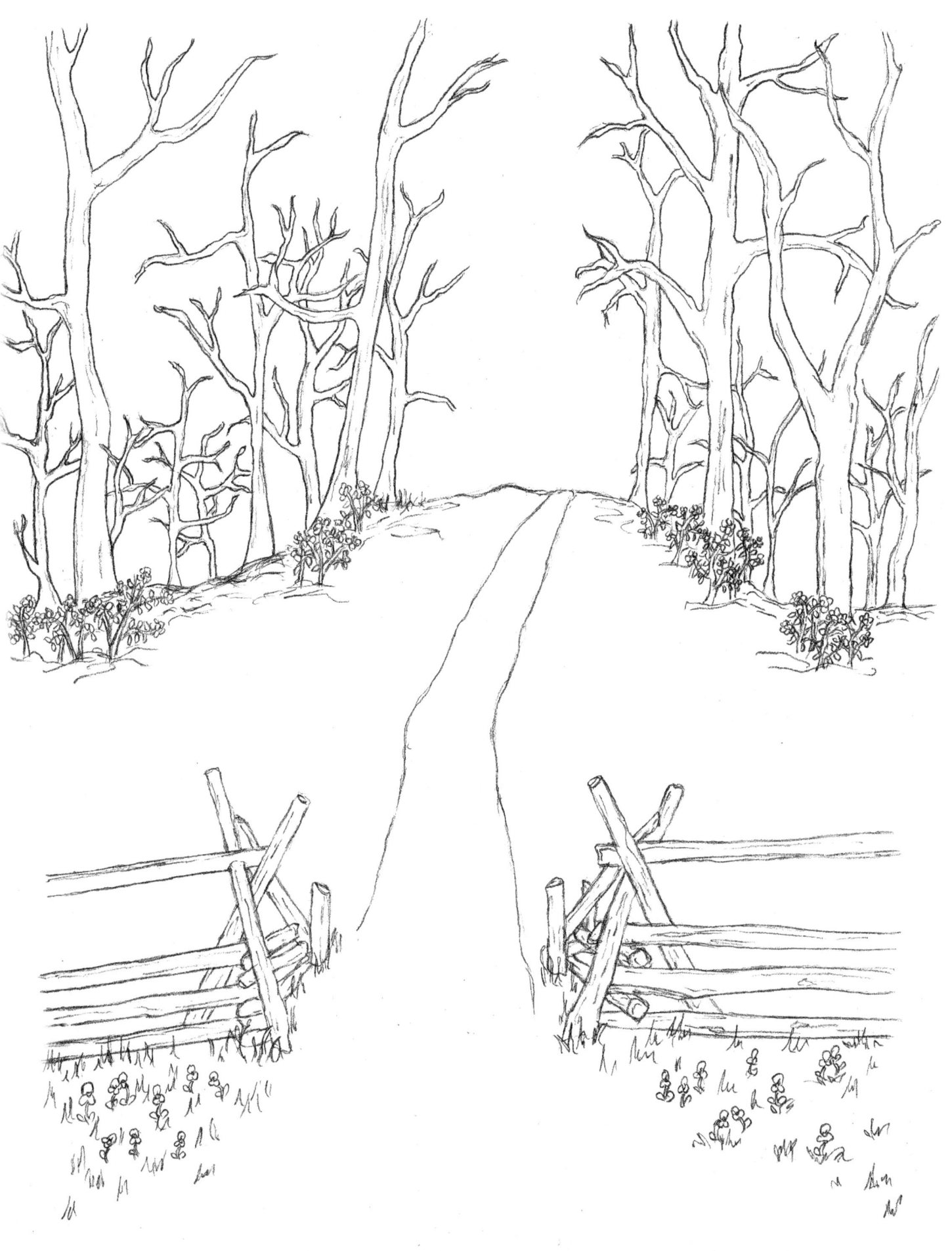

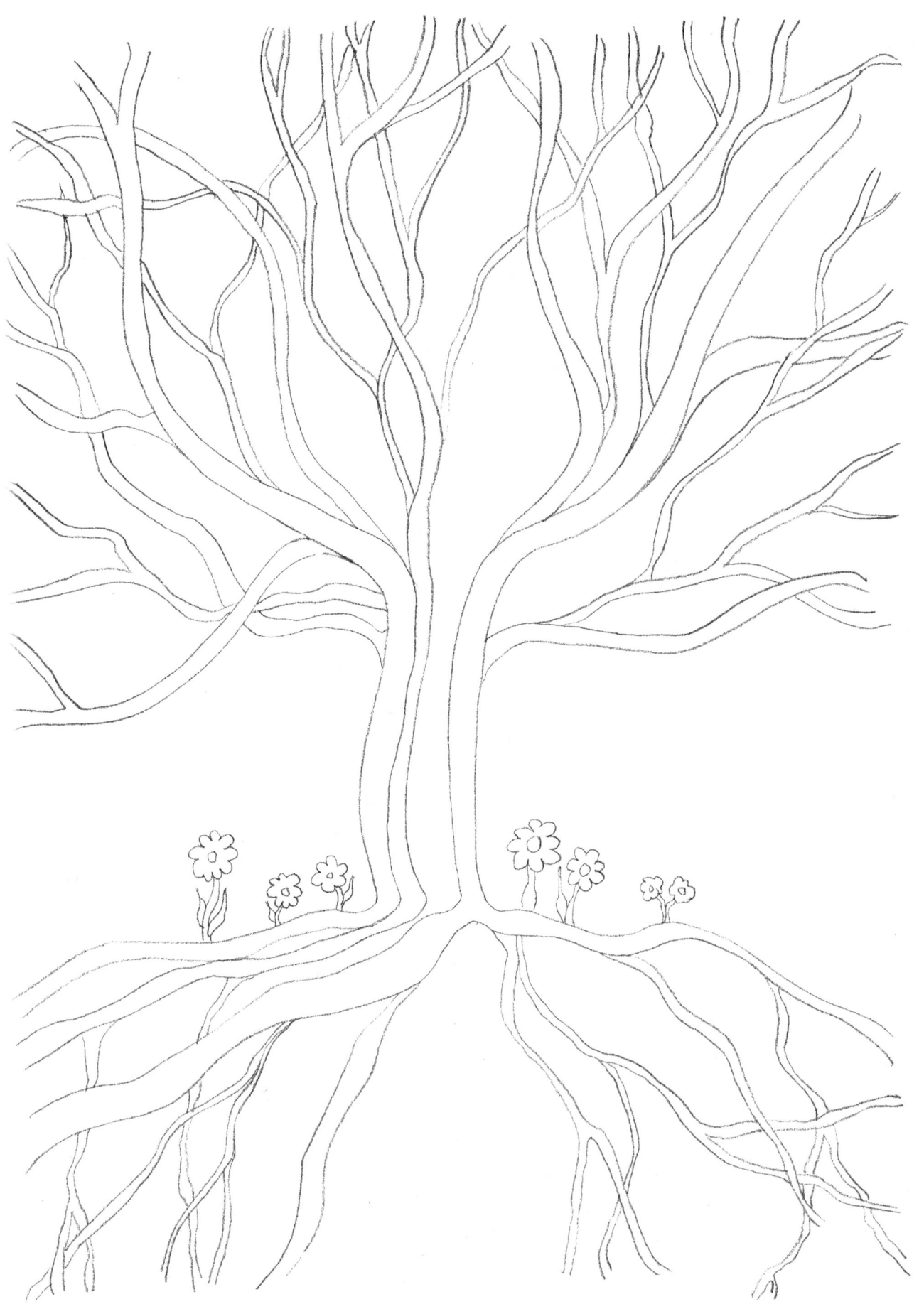

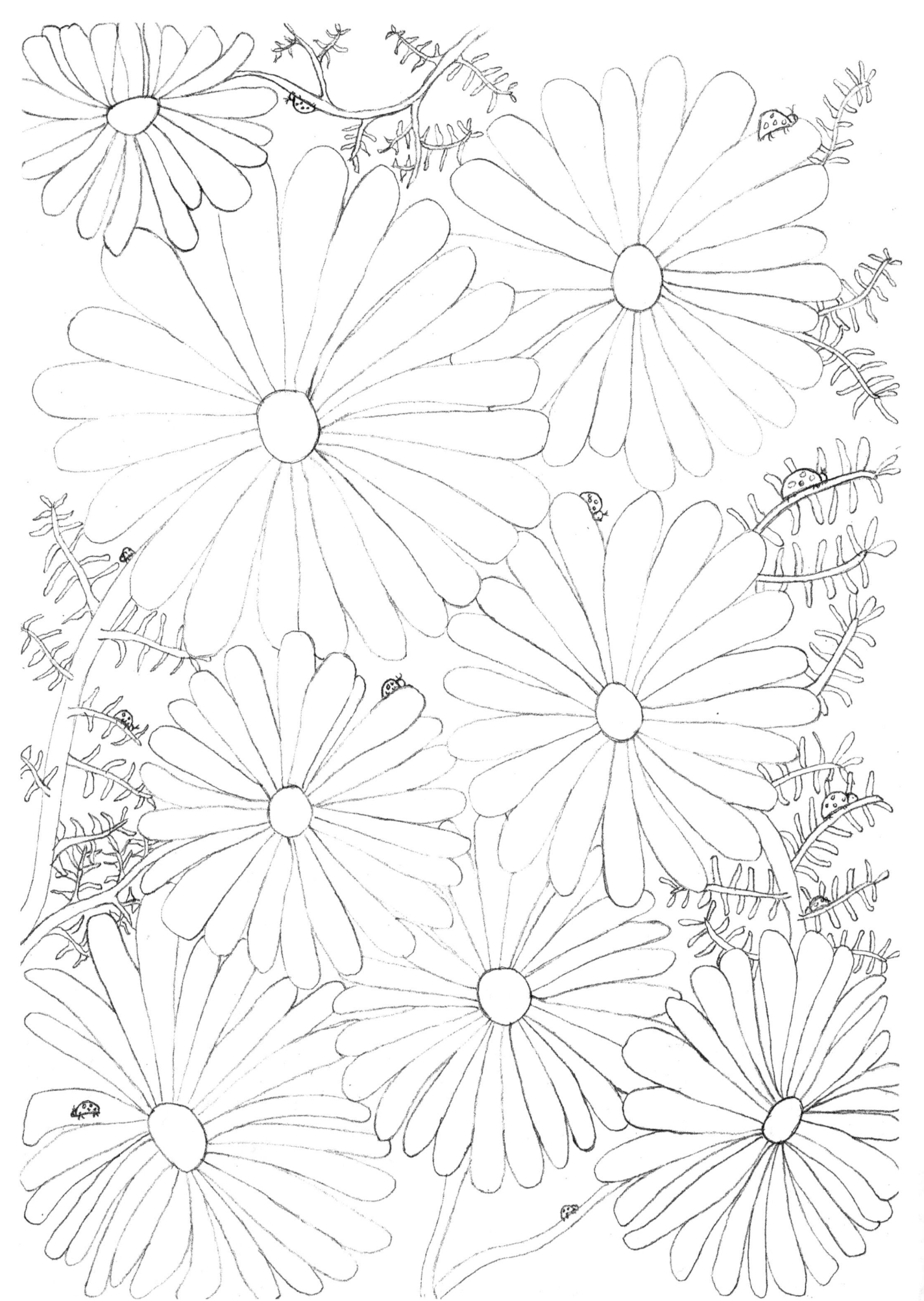

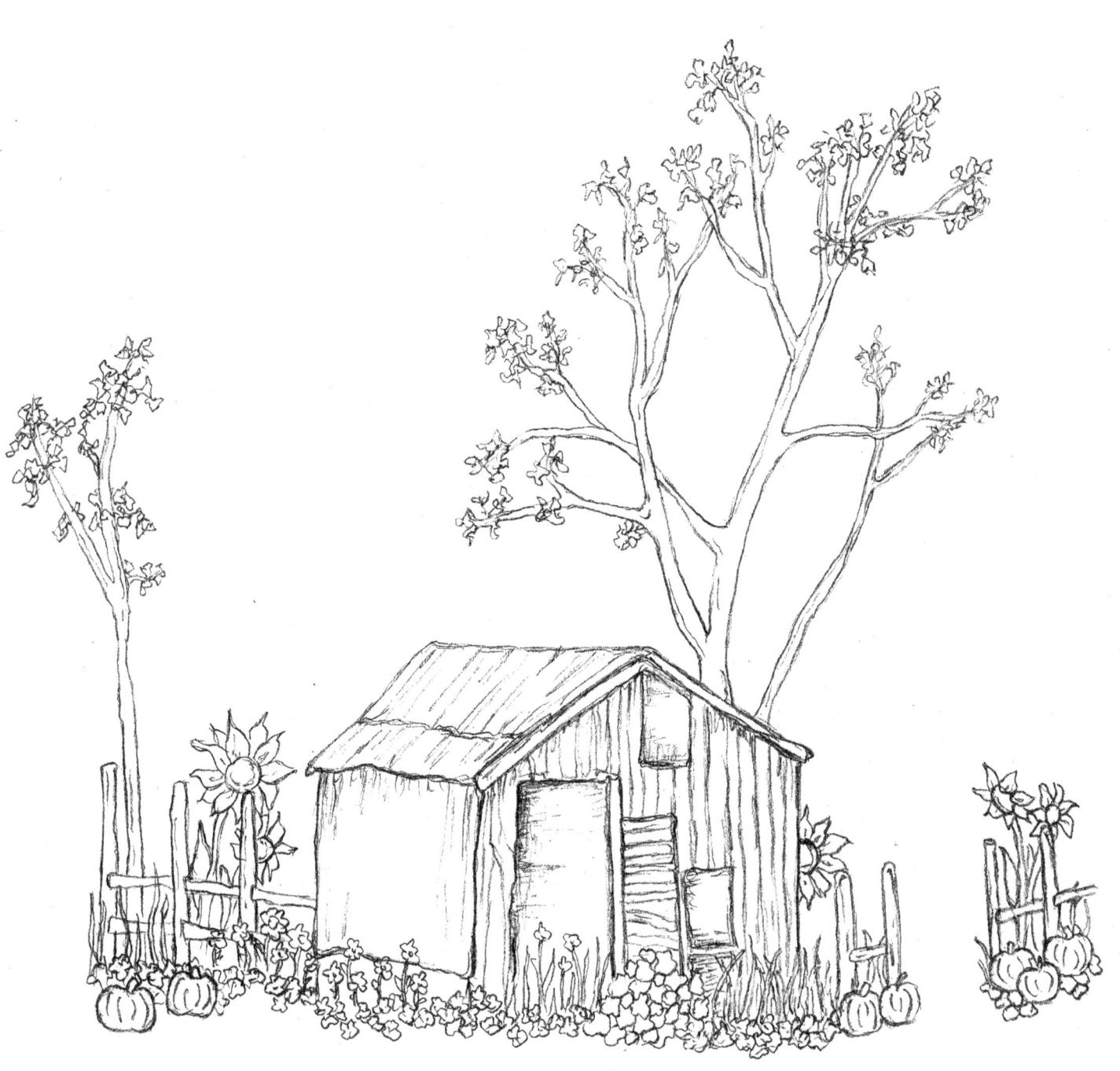

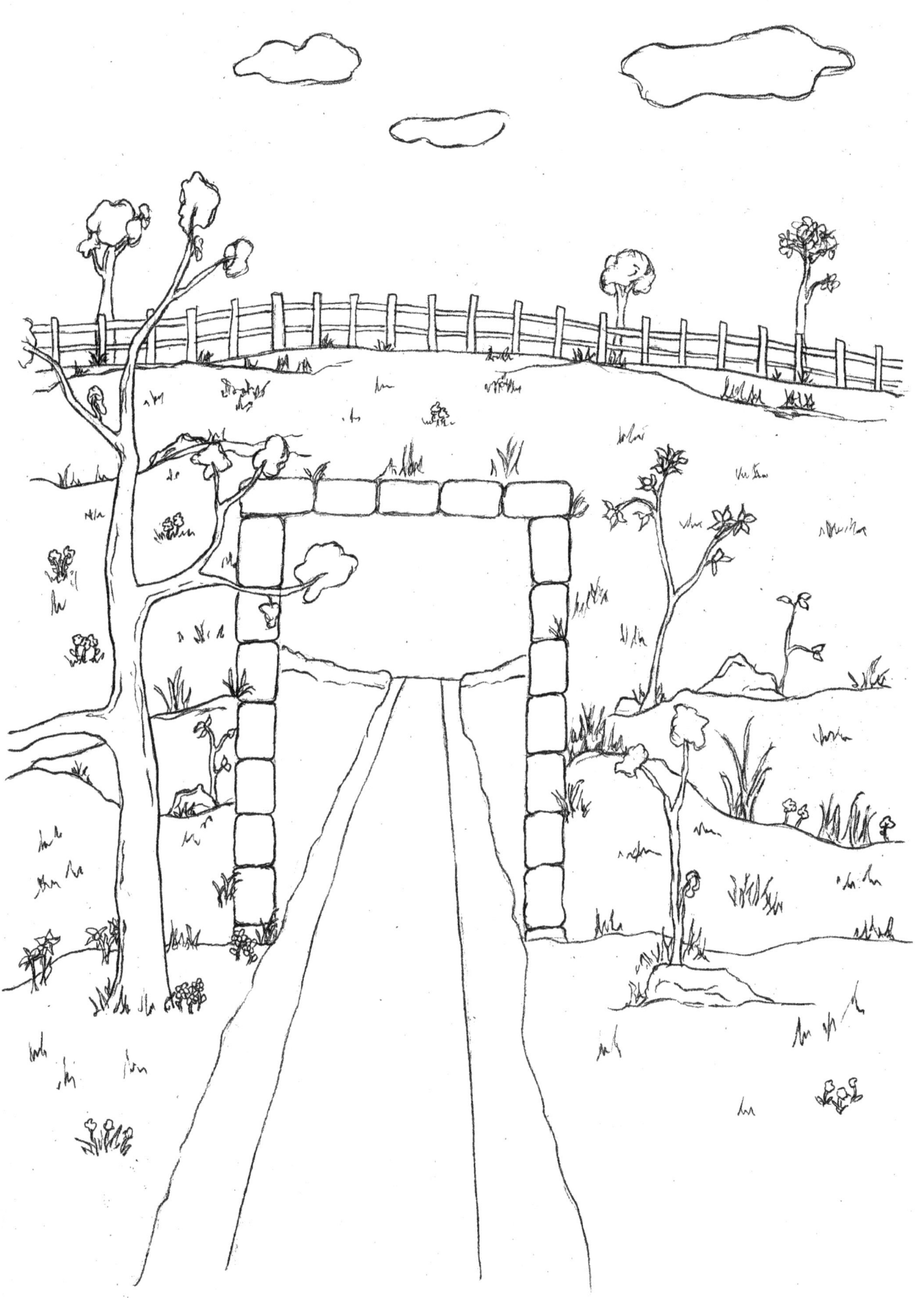

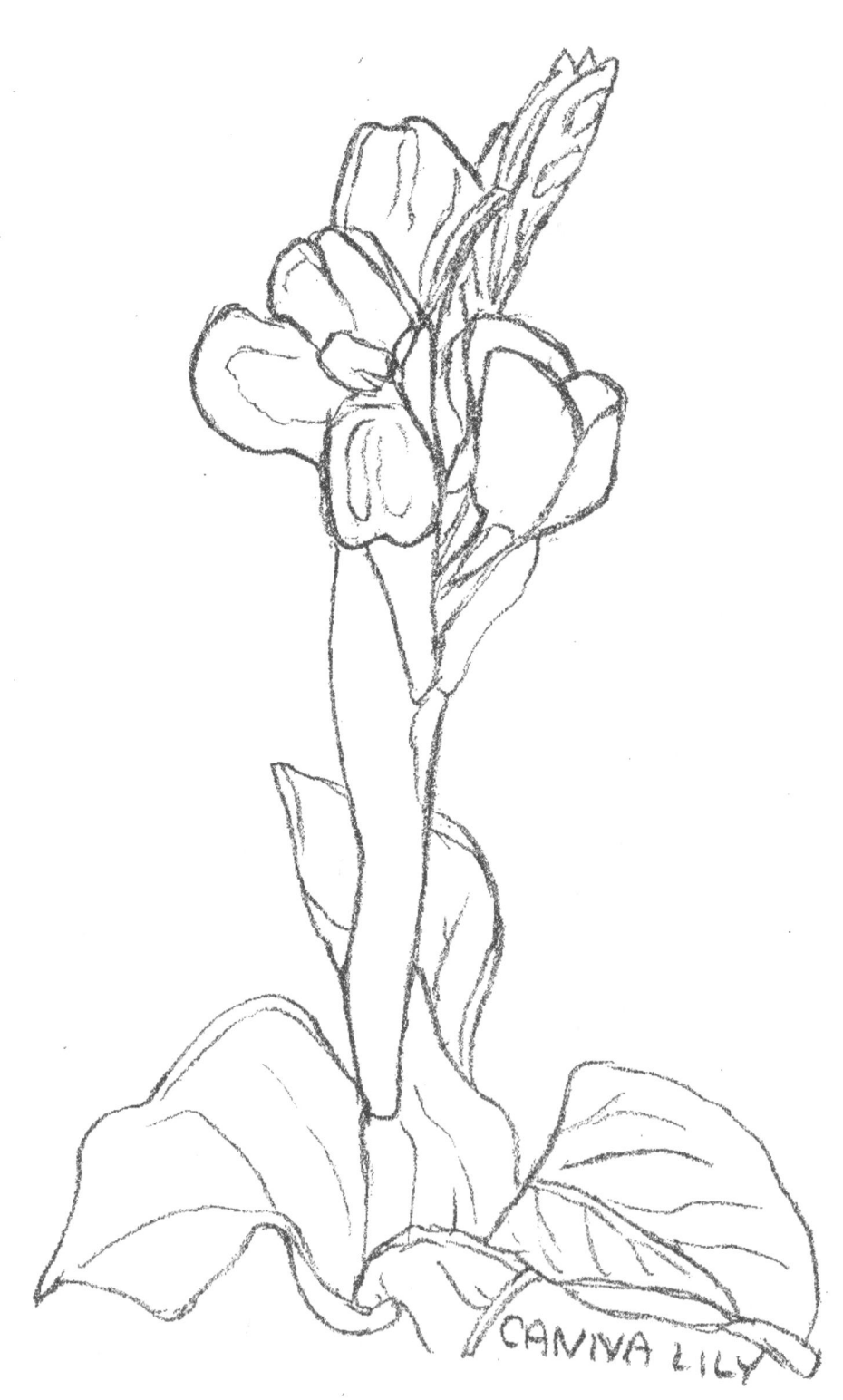

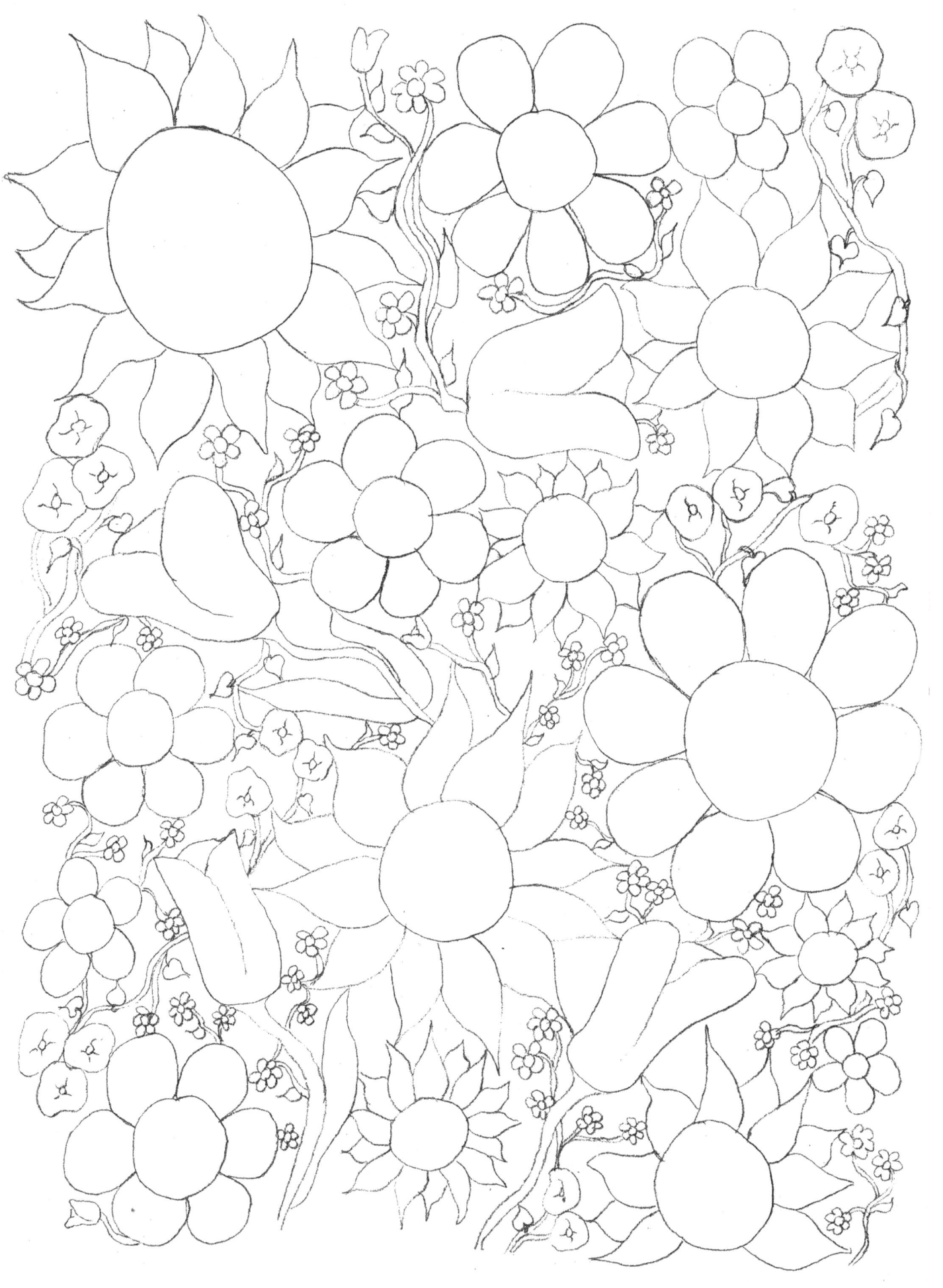

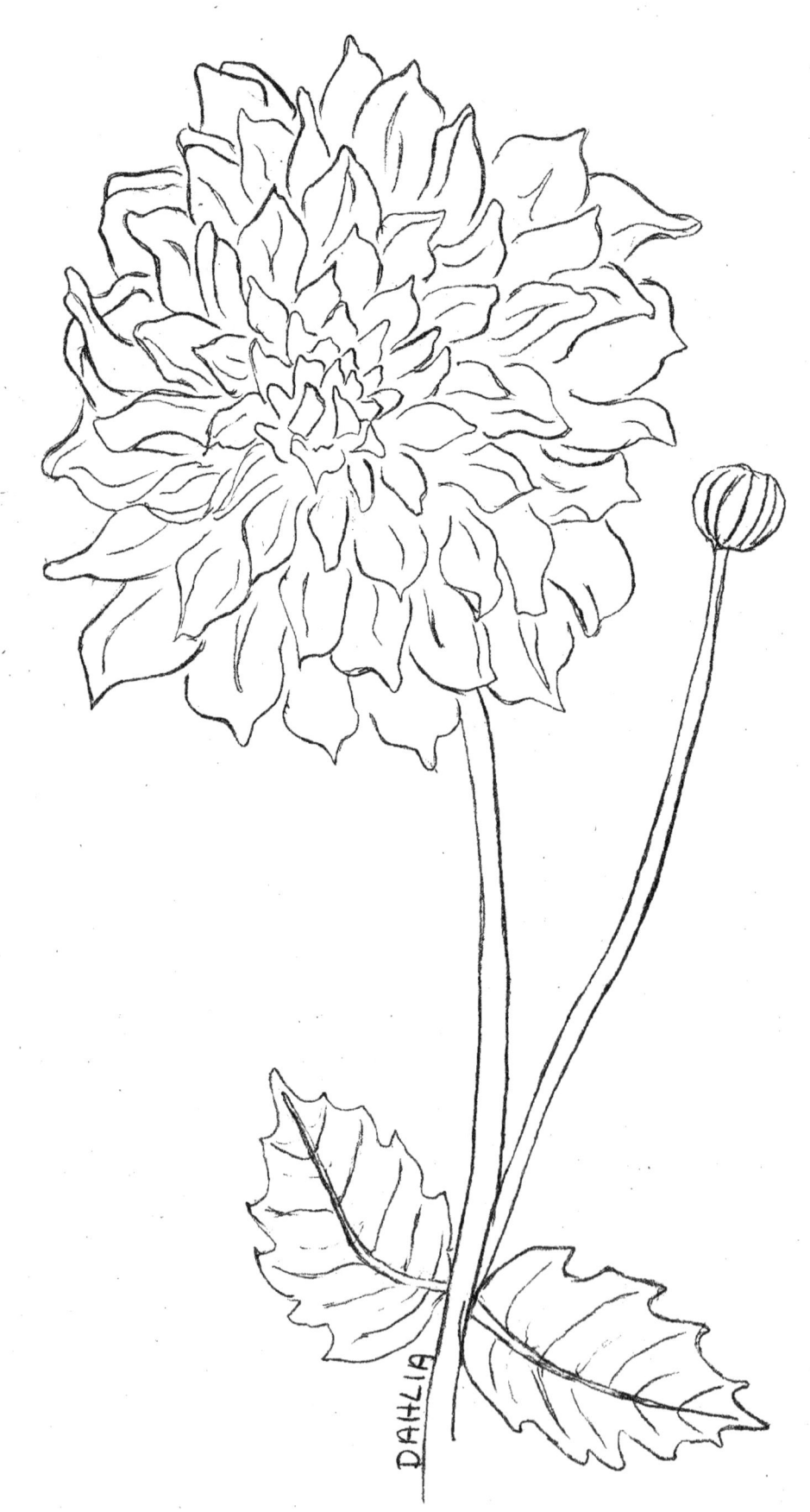
DAHLIA

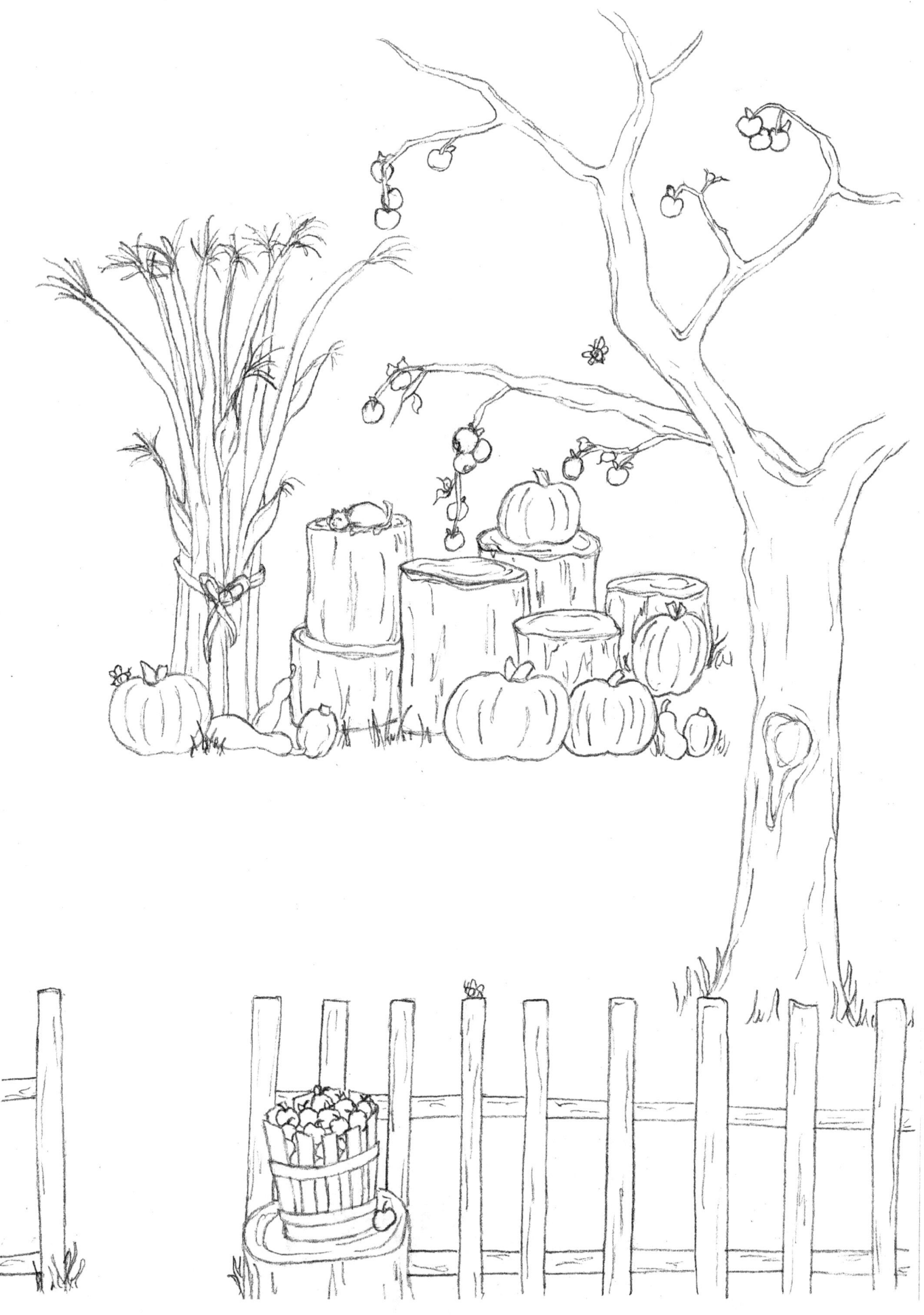

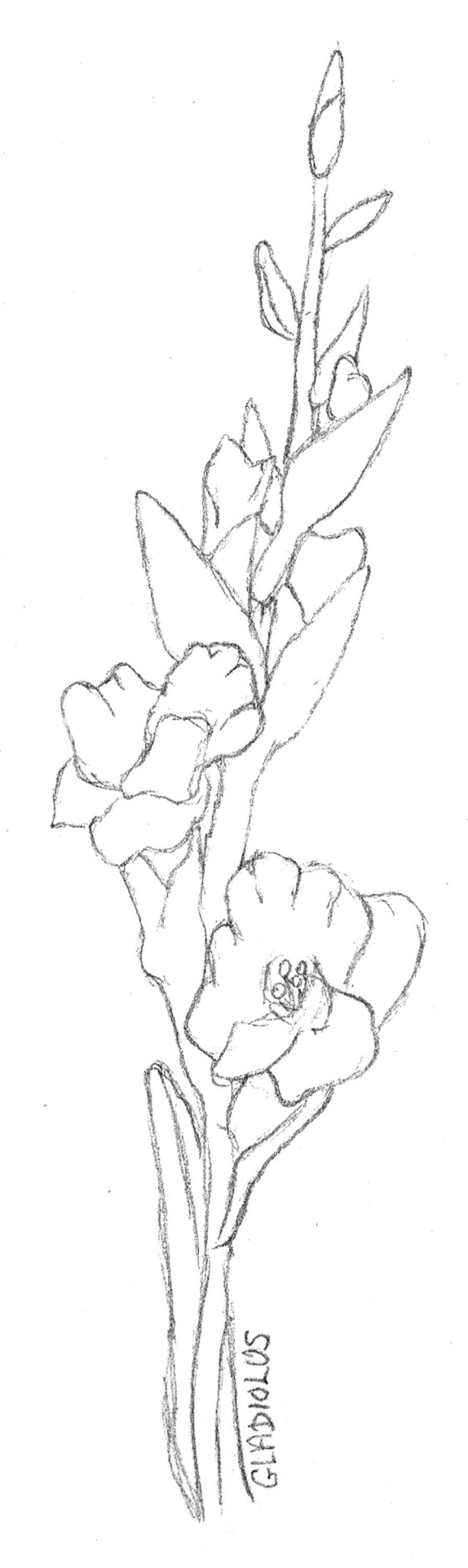

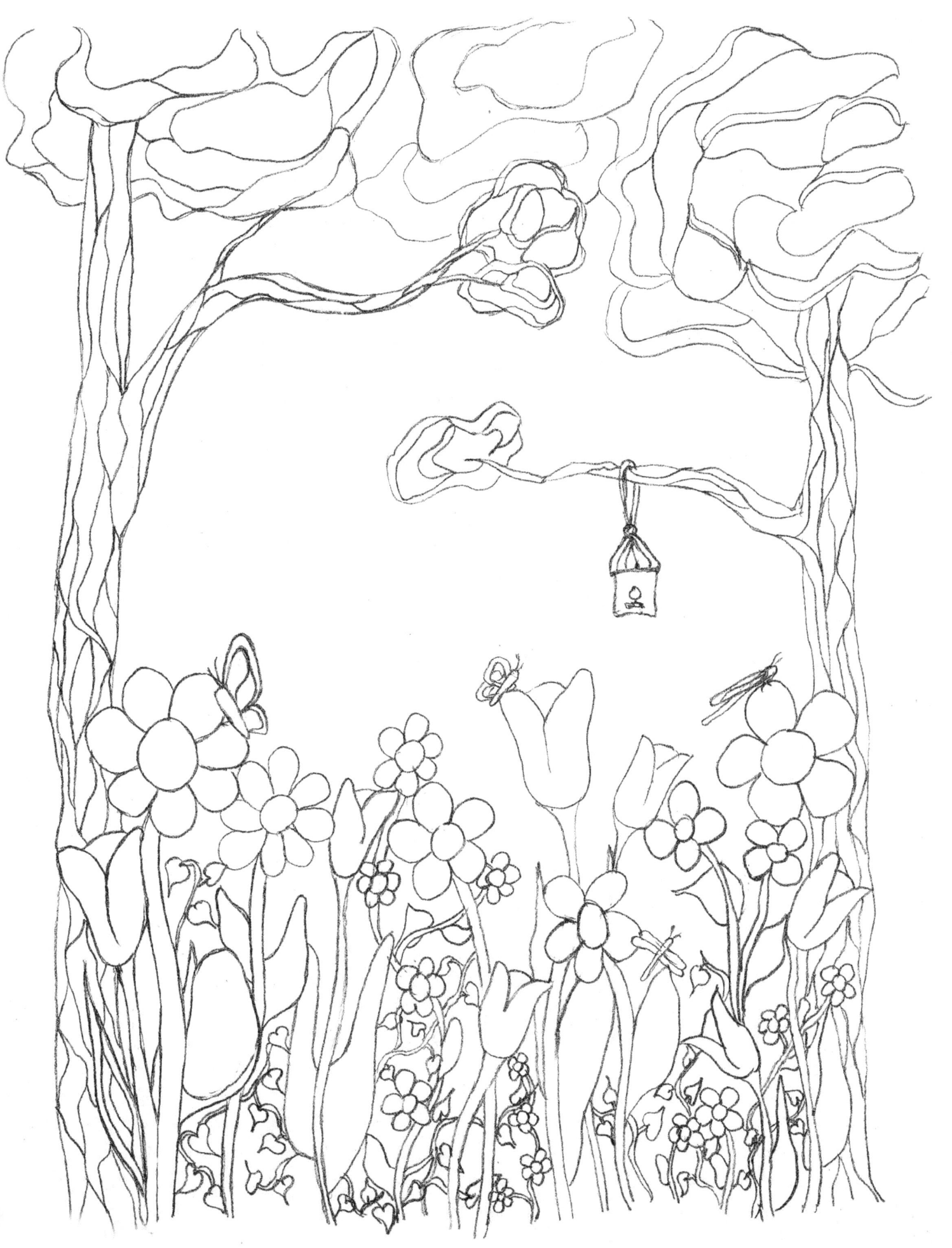

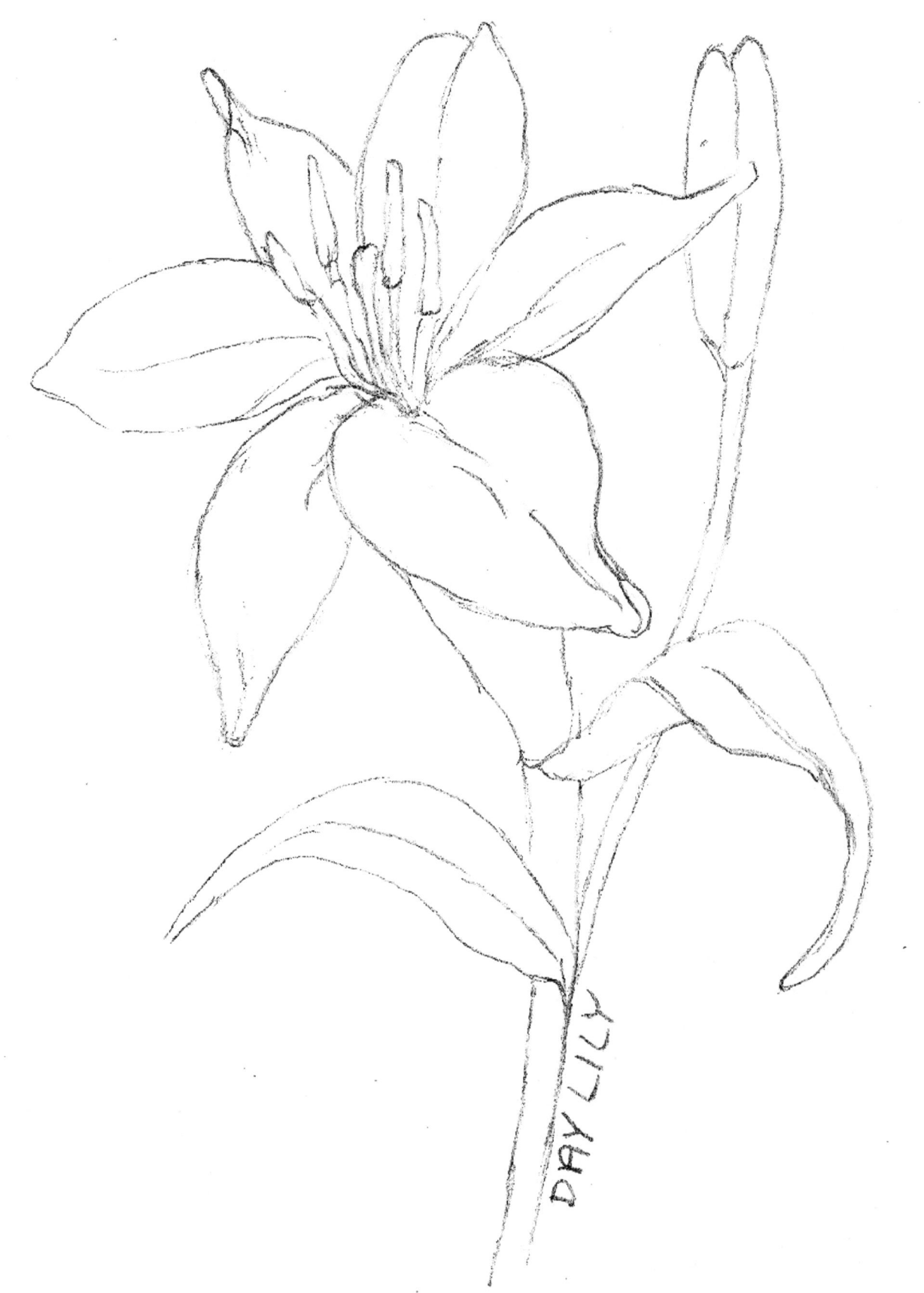

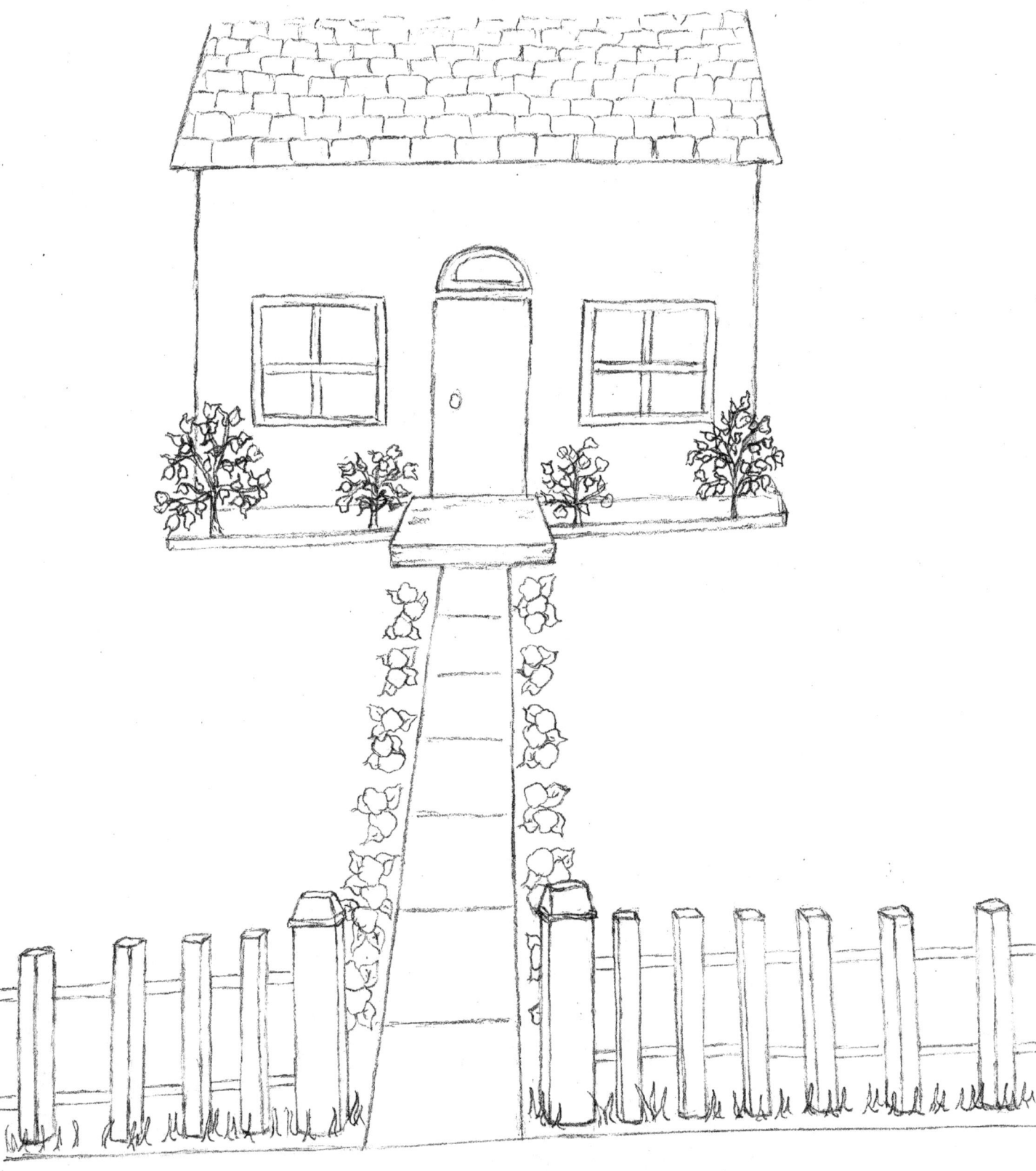

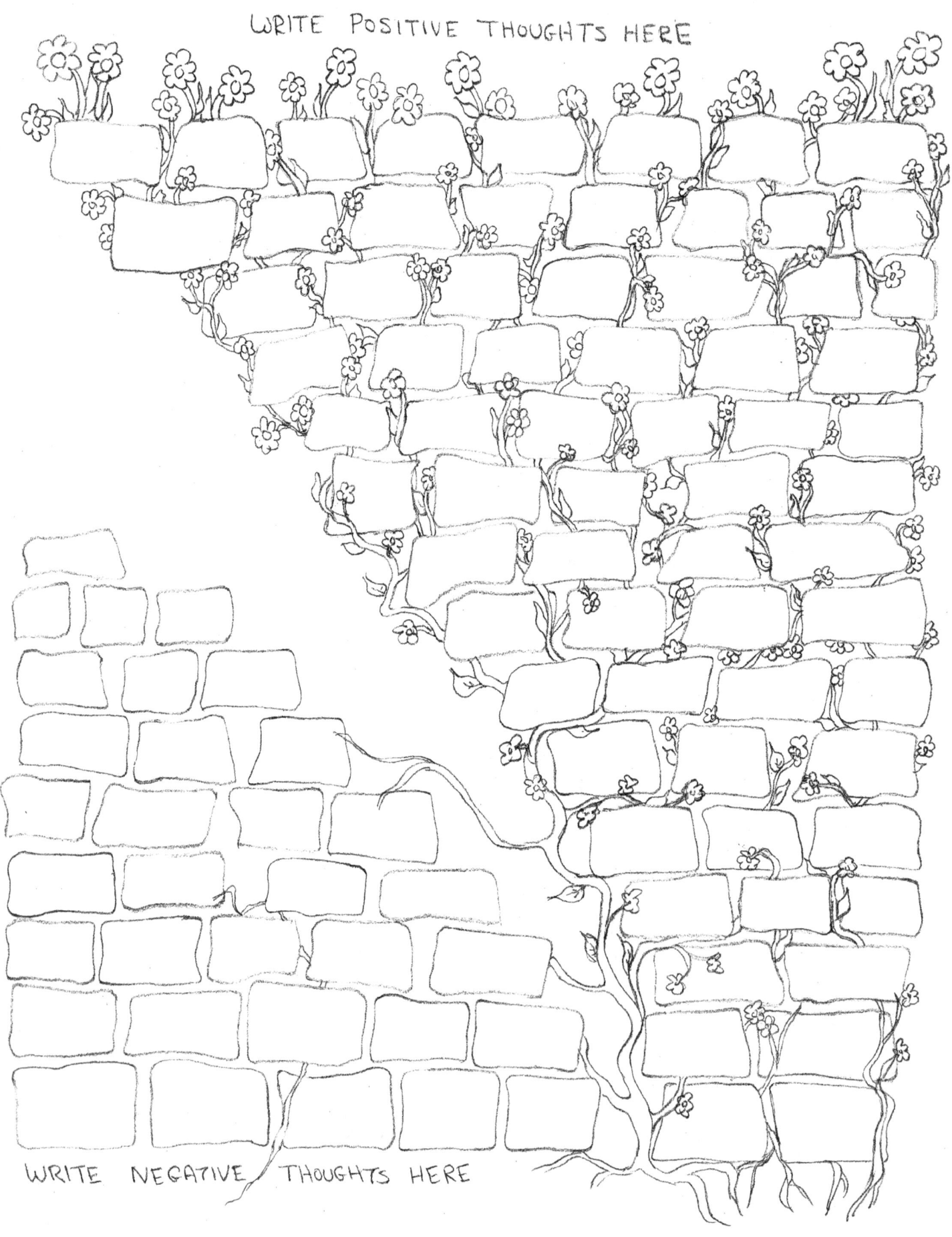

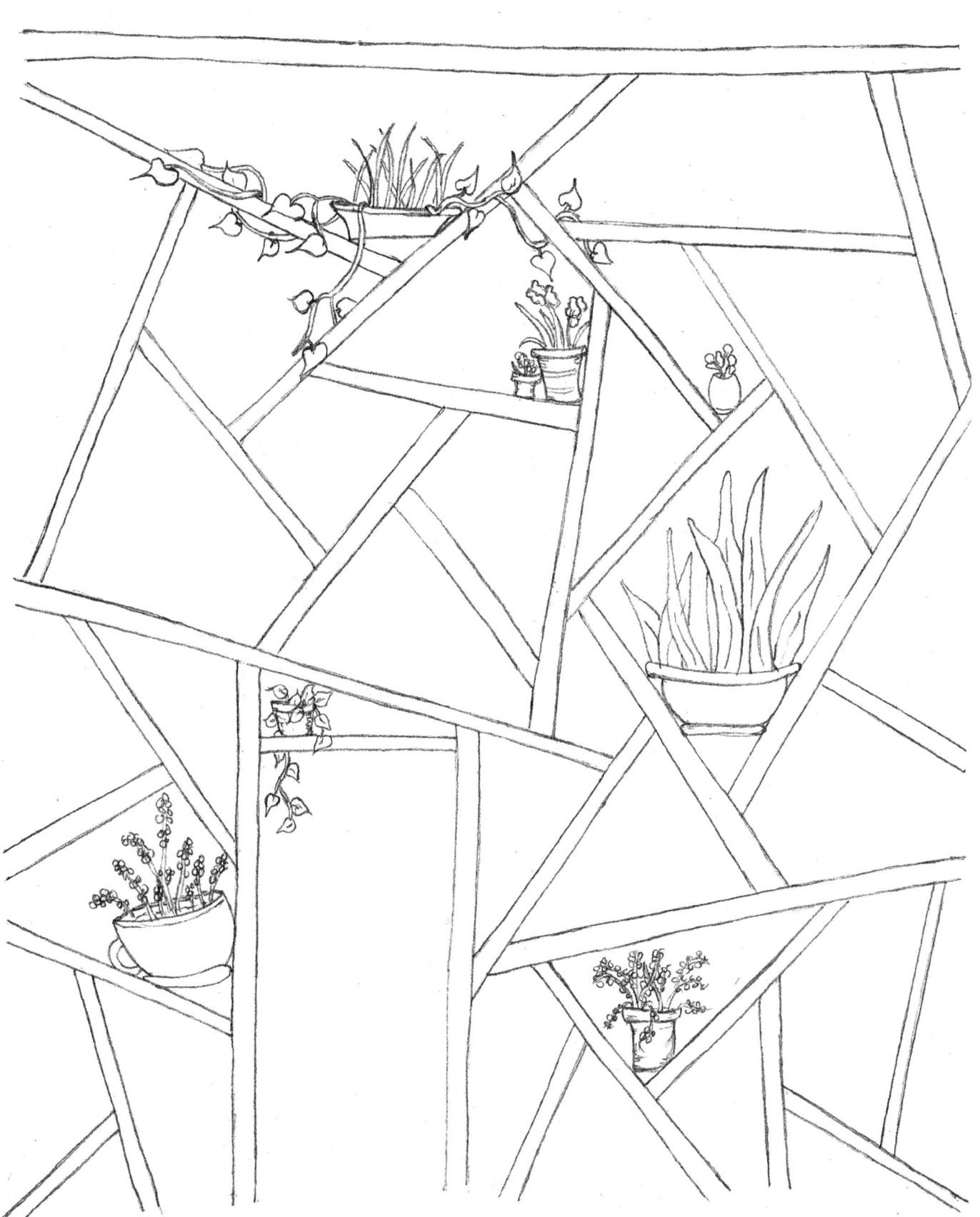

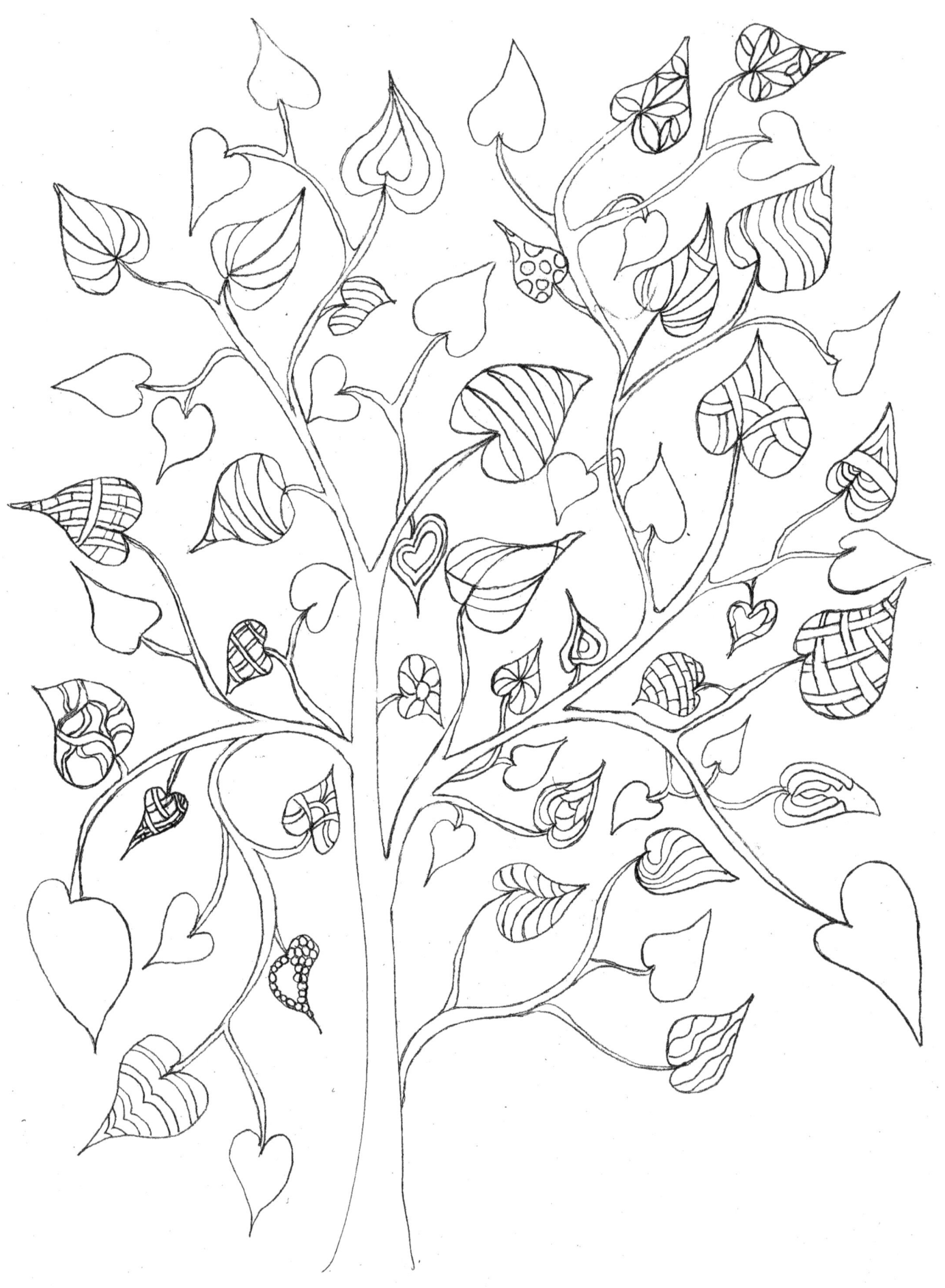

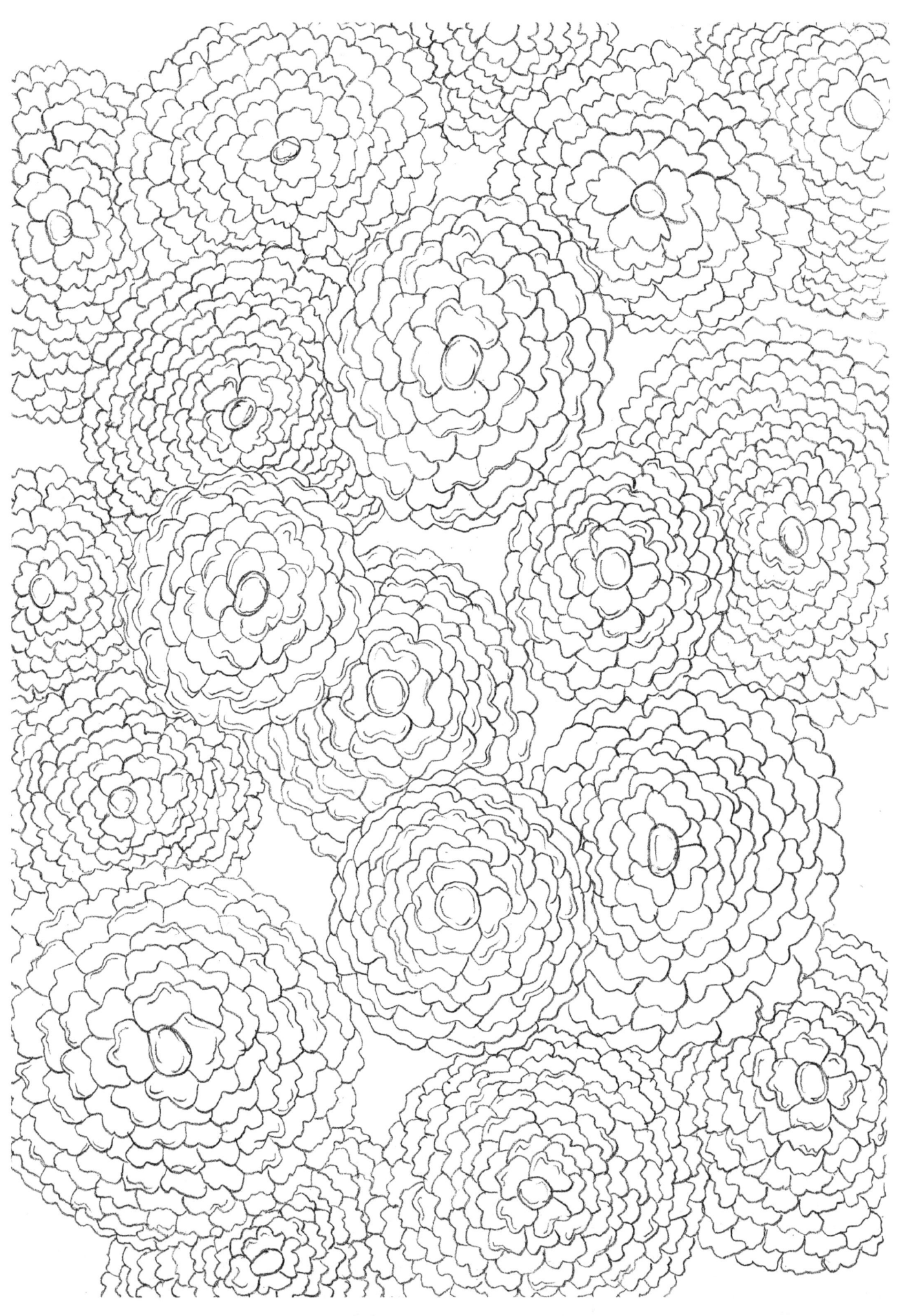

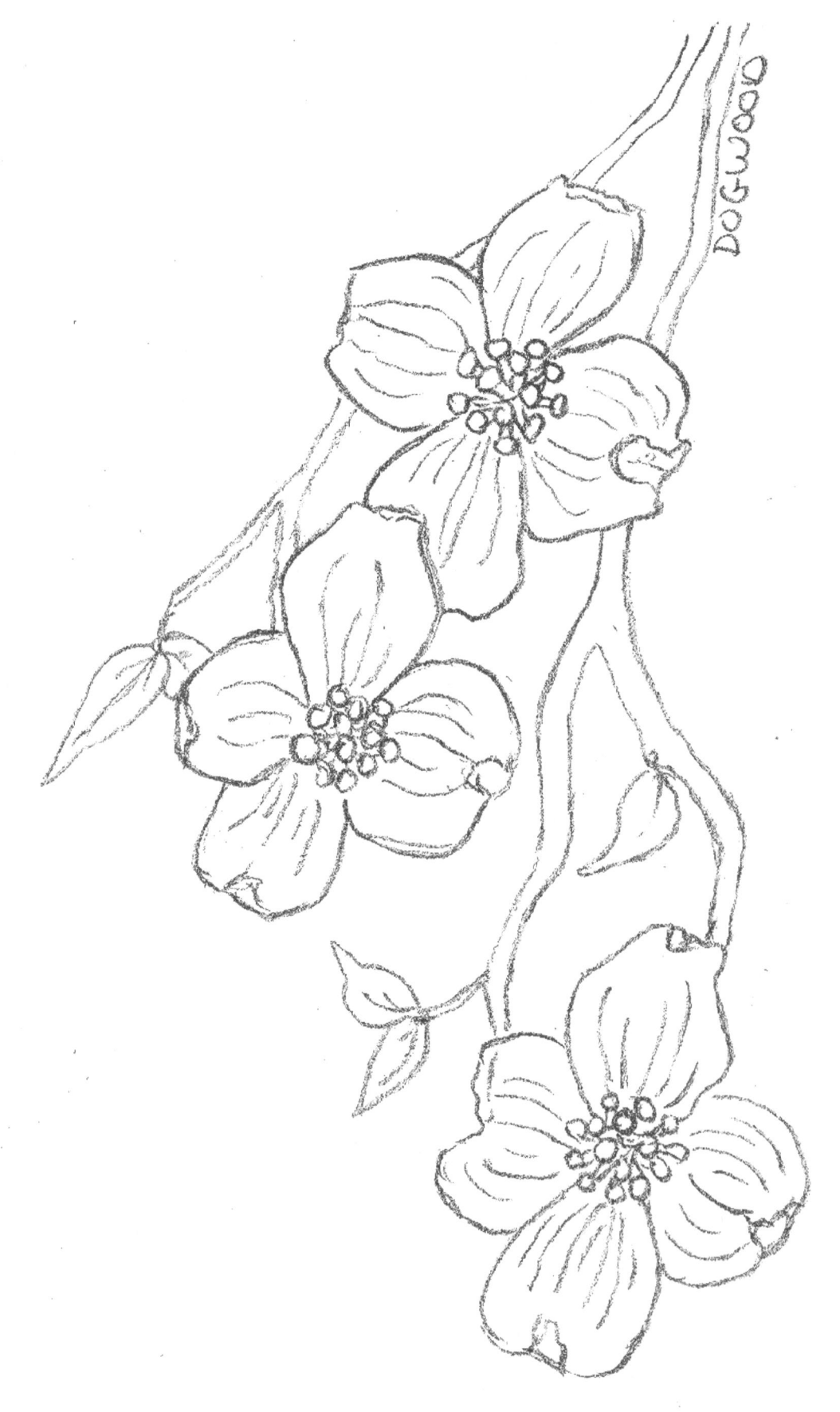

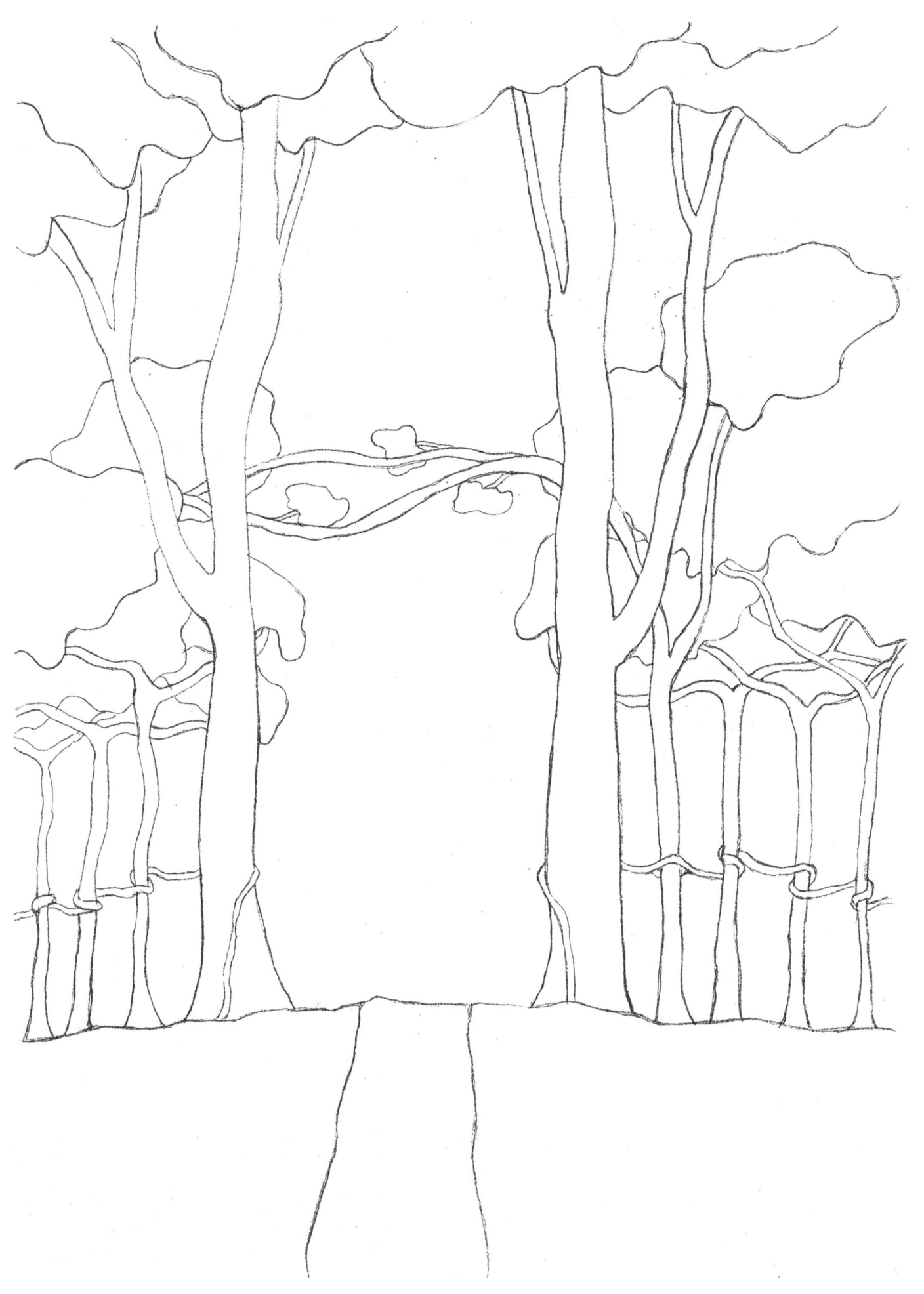

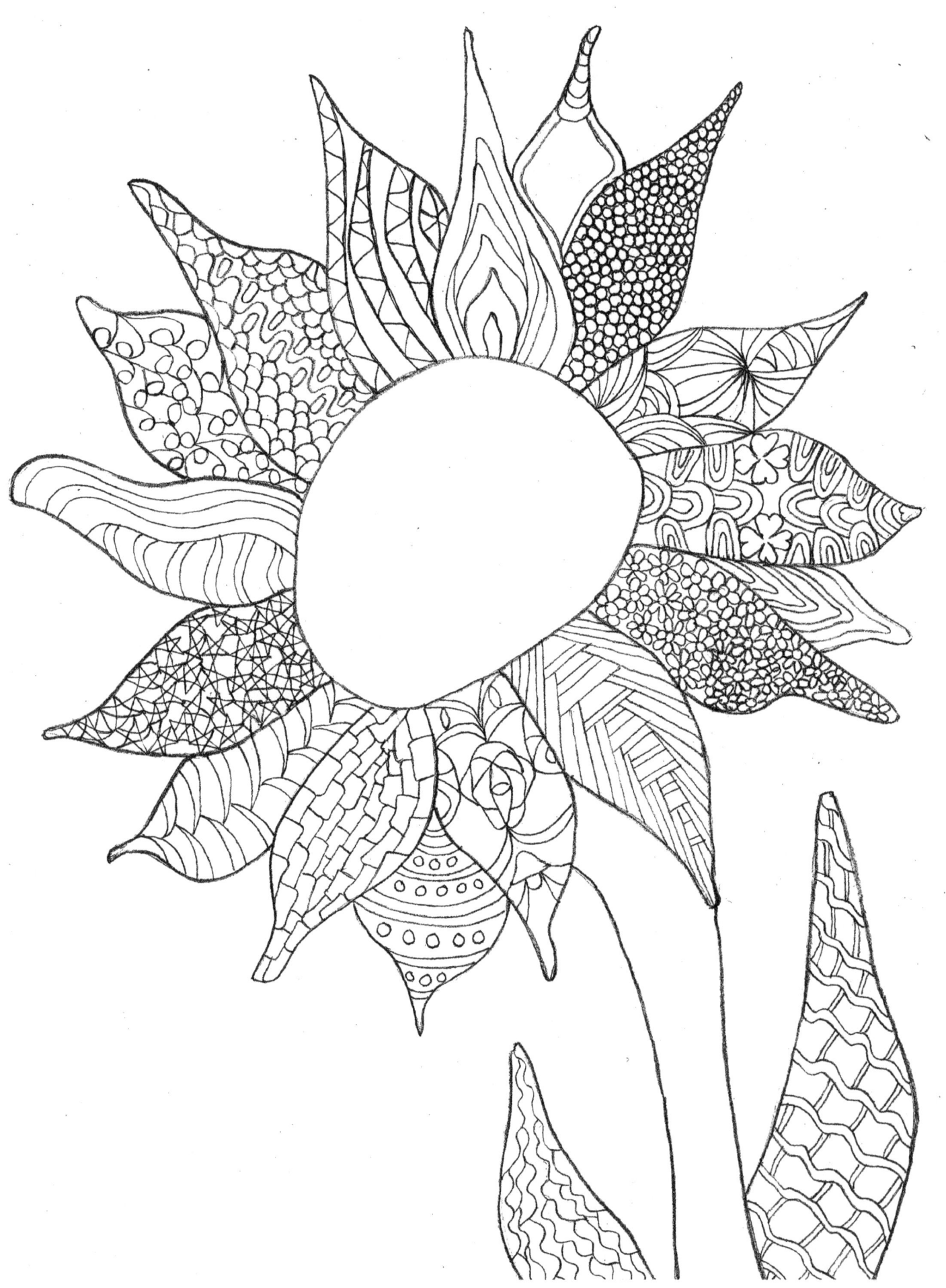

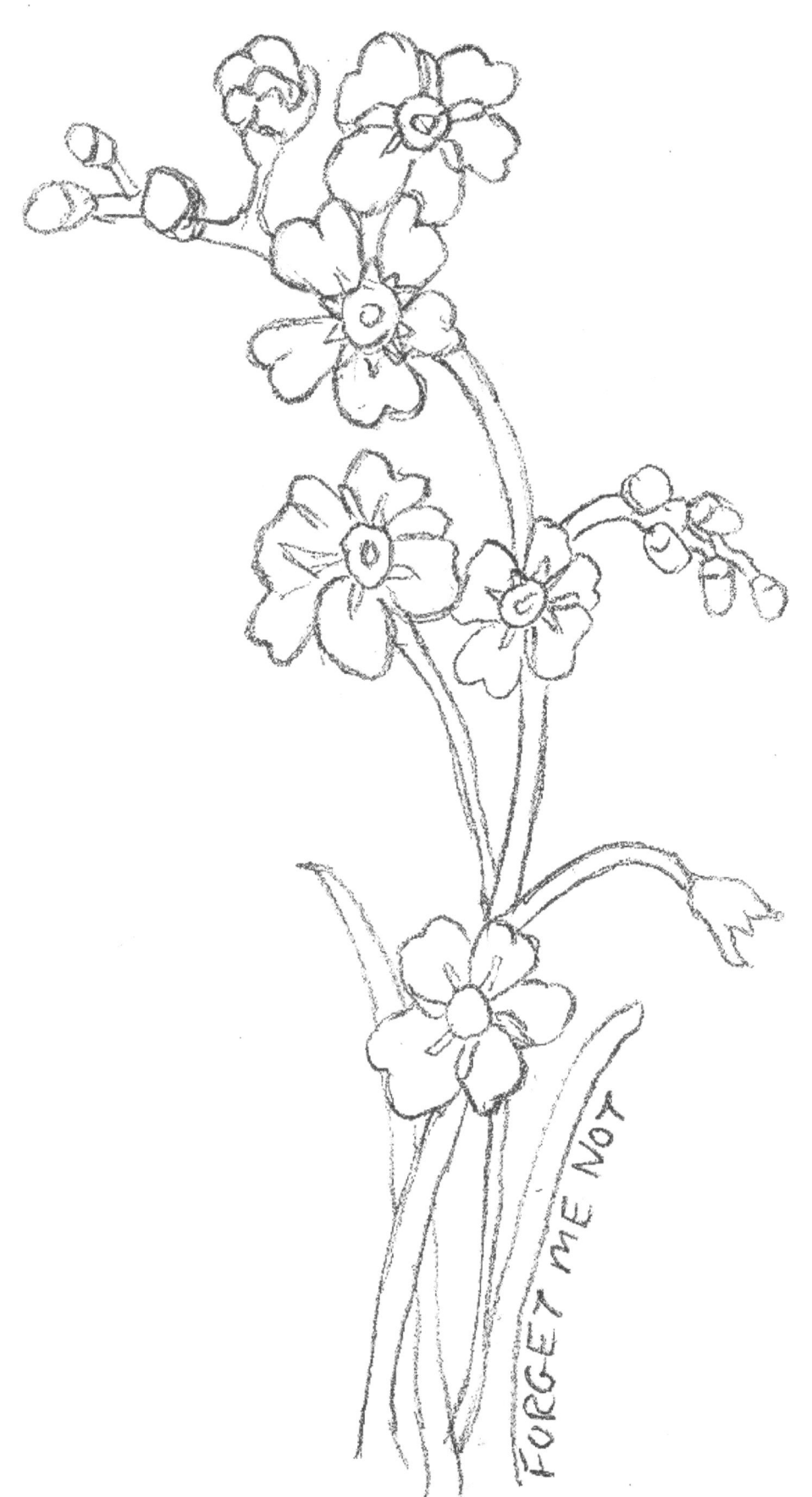

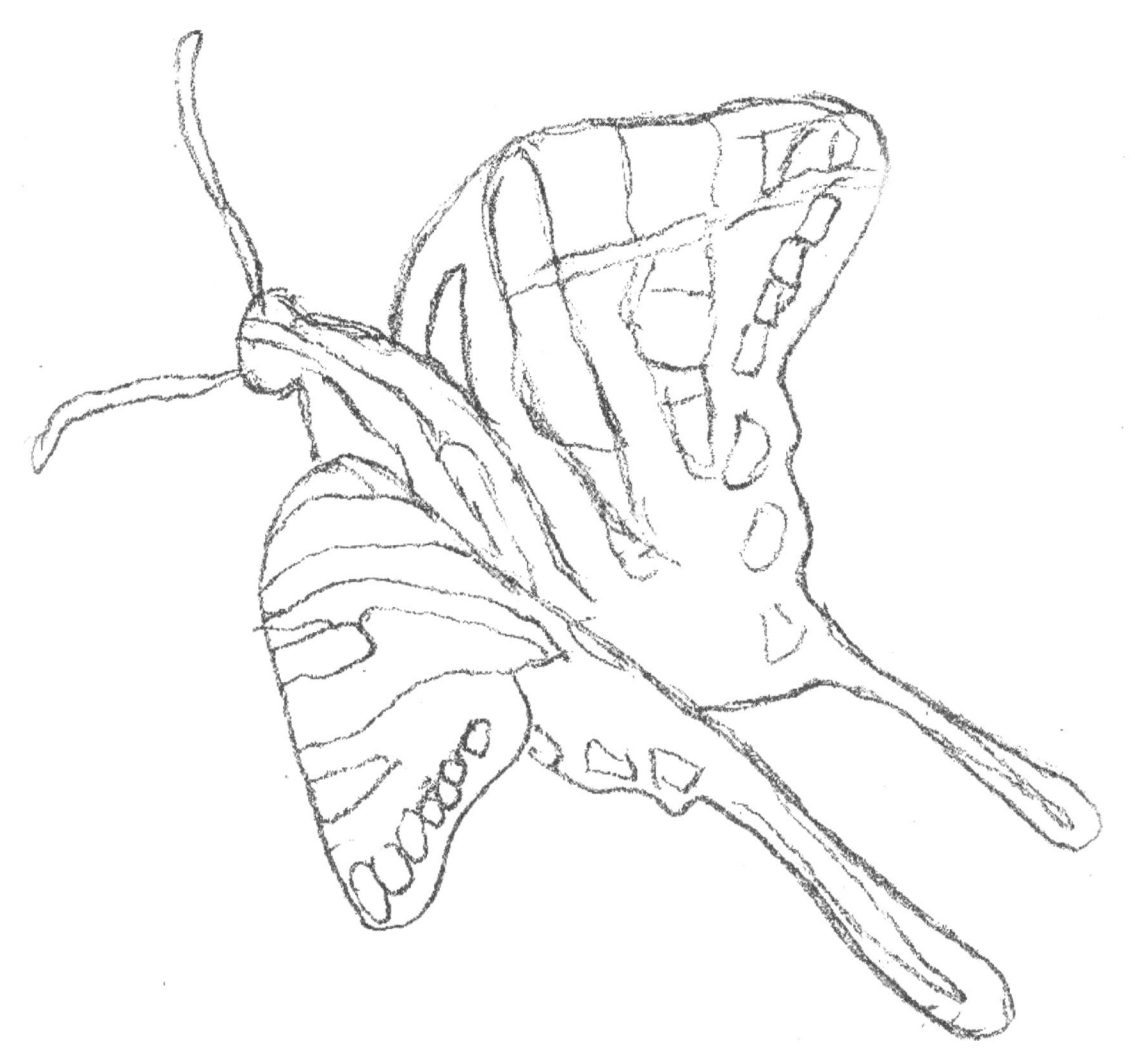

About The Author

LK Hunsaker writes fiction under two names in several genres,
all with psychological touches and centered around the arts and nature.
She has a degree in psychology with strong emphasis in art and art therapy.
With her two children grown, she now dotes on her grandchildren
in between work and sight-seeing with her husband
in beautiful Western Pennsylvania, where they settled
after twenty years of military moves.

Write The Light In
is a give-back project meant to encourage well-being and optimism
through daily struggles.
Find the blog where writers and others share how word weaving
helps them through difficult times at
ElucidatePublishing.net.

Find LK and her fiction at
LKHunsaker.com.